IMAGES
of America

GRANBY

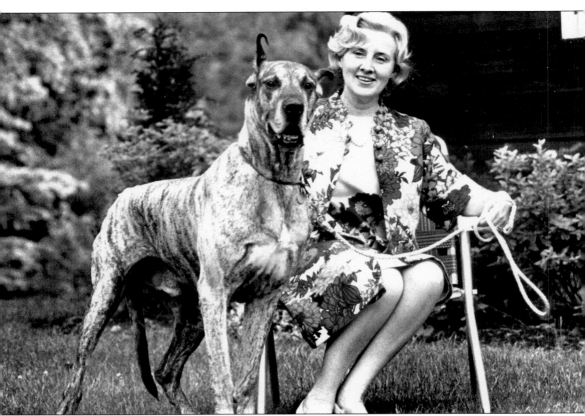

This book is dedicated to Marie Quirk, to whom we owe a great debt for preserving Granby's history. Born Gladys Marie Wagstaff, she was adopted by naturalist Burlingham Schurr and raised in Granby. She married William Quirk, a vaudeville performer in the 1920s and a stockbroker later in life. As Granby correspondent for the *Holyoke Transcript-Telegram,* Marie Quirk was intimately involved in Granby affairs. She served as our first female selectman (1973–1976), as chairperson for the Granby Conservation Commission, as vice president and president of the Granby Historical Association, and on the executive committee for the Granby bicentennial celebration.

Marie Quirk's community involvement reached well beyond the bounds of Granby. As director of the Holyoke Museum at Wistariahurst from 1951 to 1980, Quirk organized the women's committee of the Friends of the Holyoke Museum and was instrumental in the development of the Holyoke Youth Museum, Ethnic Festivals of Art, and other vital community programs. In 1970, the commissioner of the Massachusetts Department of Natural Resources appointed her to the Mount Holyoke Division of the Citizen's Advisory Committee for the proposed Connecticut River historic riverway. She was a member of the Holyoke Quota Club, the Association of Youth Museum Directors, the American Association of Museums, the Natural Science for Youth Foundation, the National Audubon Society, the Bay State Historical League, and the Friends of Art at Mount Holyoke College. She lectured in schools and colleges on natural science and authored articles on science and antiques, many of which are preserved in the archives of the Granby Historical Association. Quirk's efforts on behalf of western Massachusetts earned her inclusion in the first edition of *Who's Who of American Women.* The Marie Quirk Home in Granby, bequeathed to the Granby Historical Association, has proven invaluable for the preservation of area history. With great humility, we in Granby thank Marie Quirk.

IMAGES
of America

GRANBY

Mary Kuntz with the Granby Writing Circle

ARCADIA
PUBLISHING

Published by Arcadia Publishing
Charleston, South Carolina

Printed in the United States of America

Library of Congress Catalog Card Number: 2002106588

For all general information contact Arcadia Publishing at:
Telephone 843-853-2070
Fax 843-853-0044
E-mail sales@arcadiapublishing.com
For customer service and orders:
Toll-Free 1-888-313-2665

Visit us on the Internet at www.arcadiapublishing.com

CONTENTS

ACKNOWLEDGMENTS

The Granby Writing Circle, the Council on Aging, and the Historical Association wish to thank the Granby Cultural Council, a local agency, and the Massachusetts Cultural Council, a state agency, for financial support in the initial stages of this book. Special thanks go to Nancy Gluek and Terry Johnson of the Granby Historical Association, without whose assistance this book would not be possible, and to Betty Innocent, director of the Granby Council on Aging, whose care of legal and clerical matters was invaluable.

We appreciate the help of the citizens and organizations of Granby who gleaned information and pictures from their closets, drawers, cellars, and attics—namely, the Granby Church of Christ, Congregational; Immaculate Heart of Mary Catholic Church; Fr. James McCurry of St. Hyacinth's Seminary; Catherine Camp; Dale Mugnier Clark; Camille Cloutier; Denise Dufresne; Jeffery Dwinell; Roger Fournier; Dean Hatch; Evelyn Hatch; Viola Lyman Hatch; Darcy Henry; Warren McKinstry; Martin Merrill; Kornel Nash; Linda Parker; and Ruth Ruel. We also humbly acknowledge those who have gone before. *The Bicentennial Book of Granby*, by Margaret W. Dickinson, published in 1968 by the town of Granby, has been an invaluable source of information for *Granby*.

A personal thanks goes to Dolores Danek, Betty Fredette, and June Graves, members of the Granby Writing Circle, whose endless pursuit of photographs and information, and countless hours of assistance, brought this book to publication.

—Mary Kuntz

INTRODUCTION

As with most New England towns, the town of Granby finds its roots in the inland push of early settlers at the end of the Puritan immigration, which lasted from 1620 to 1640. At that time, a fairly homogenous society of a million settlers, descendants of the original Puritan stock, populated New England. As distances from homes to schools and meetinghouses increased, splinter congregations formed, building new schools and meetinghouses and eventually establishing new towns.

By the middle of the 18th century, settlers had pushed westward and northward from coastal towns to the fertile Connecticut River Valley and the area bounded by the Mount Tom and Mount Holyoke Ranges, rich in game and timber. The town of Hadley and the Congregational Society of Hadley were established in 1659, north of the Mount Holyoke Range. That congregation eventually expanded south of the Mount Holyoke Range and established the Congregational Church of South Hadley, which became the town of South Hadley. Although conditions on the frontier were still unsettled in 1727, Ebenezer Taylor, John Smith, Ephraim Nash, and John Lane pushed eastward from South Hadley to settle in the area now known as Granby. On February 18, 1762, the Second Precinct of South Hadley erected a separate meetinghouse at the present intersection of Amherst and West Streets in Granby and formed the Church of Christ Society. In 1768, that group established the township of Granby, named after John Manners, the Marquis of Granby, an English hero of the Seven Years' War.

The Church of Christ Society continued to worship in the original meetinghouse until 1820, when it was decided that a new building should be erected, as the community had spread even farther east. The original settlement area became known as West Parish, and the newer part of town, East Parish.

At this time, New England culture had begun to bloom. More organized education, greater personal wealth, increased contact among towns, travel outside the fledgling country, and greater security from raids allowed the population to mature. As the post–Revolutionary War Congregational Church became more Unitarian, the link between church and state dissolved, leading towns to build separate buildings for worship and government, the architecture of each a reflection of their uses. Into this society came a new breed of New England builder—the architect—one of whom was Elias Carter. The East Parish Society engaged Carter to construct a church, erecting it on the town common's highest point, making it the most prominent structure in Granby. One hundred thirty years later, the town's Catholic population bought a

parcel of land that included the second-highest point on the common, and they erected the Immaculate Heart of Mary Church, facing the Church of Christ as a sign of unity.

Through the years, Granby has managed to keep its rural New England character, despite burgeoning populations in surrounding towns. Town zoning forbids heavy industry. Vintage homes embrace their younger neighbors, producing an eclectic mix of old and new. The town's location is ideal—far from the flood plain of the Connecticut River, yet not encroaching on the unforgiving Berkshire Hills. Fierce storms seem to skirt around it to the north or the south, weather patterns that may have reinforced the early settlers' ideas of Divine Providence.

Town meetings still serve as a viable form of government for Granby's 6,000 residents, providing a venue for renewing or dissolving old friendships, and a source of endless entertainment or dismay for newcomers. One of the few remaining private telephone companies in the nation, the Granby Telephone and Telegraph Company is a source of both pride and consternation for the residents—pride because it reinforces the basic sense of solid independence and continuity among longtime residents, consternation because many calls to adjoining towns are still toll calls.

The population of Granby can be divided into three categories: descendants of the founders; longtime residents who are not descendants of the founders but who have made their mark on the town; and newcomers, some of whom are stationed at Westover Air Reserve Base and some of whom are professionals who use Granby as a bedroom community.

The purpose of *Granby* is to blend images of our past with facts and folklore, and to show the development of Granby as a physical and social community. From its first settlement in 1727 to the present day, internal and external events have formed a special town, at some times more harmonious than at others, but always New England.

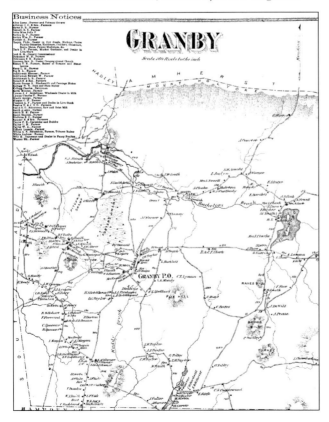

This c. 1873 map of Granby shows many original farms, homes, and schools. Roads were little more than dirt trails that allowed for the passage of oxcarts. According to local legend, during a dispute over the location of the new meetinghouse, members of the Granby congregation stole and hid the center post of the South Hadley church in Pichwam (Pitchawam) Swamp, seen in the upper left section of the map.

One

EARLY GRANBY

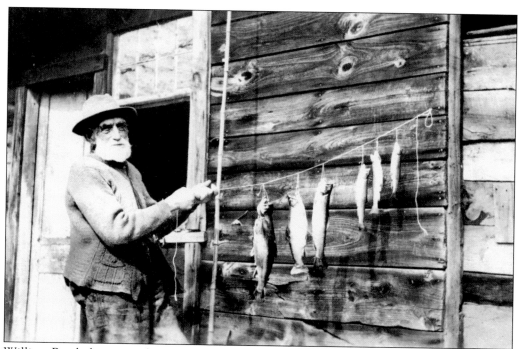

William Batchelor strings his catch of the day at his fishing shed on Batchelor Brook.

This photograph shows Rev. Eli Moody, pastor of the West Parish Church in Granby, who accepted a call to the East Parish Church in 1836 in order to unite the two parishes, thereby uniting the town of Granby. Rev. Joseph Knight, pastor of the East Parish congregation from 1829 to 1836, mounted an effort to unite the East Parish and the West Parish for financial reasons. He succeeded but lost his pastorate in the process, as the united congregation elected Moody as pastor. The West Parish continued to exist with a few dissenting members until the meetinghouse was sold and dismantled in 1822.

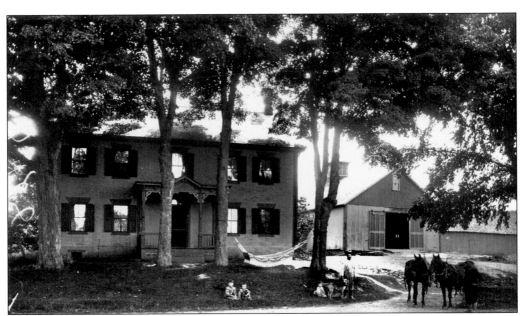

This house at 94 Amherst Street is said to have been built for Moody when he became assistant pastor of the West Parish Church.

Noah Ferry and his family settled on West State Street in Granby between 1731 and 1740, with many more members following thereafter. The Ferry Homestead was established c. 1770 at 64 Ferry Hill Road, where Capt. Luther Ferry made furniture and caskets in his carpenter shop. This photograph shows their descendant Charles W. Ferry, who was a prominent member of the community and was postmaster in 1879.

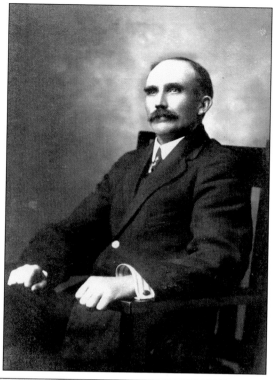

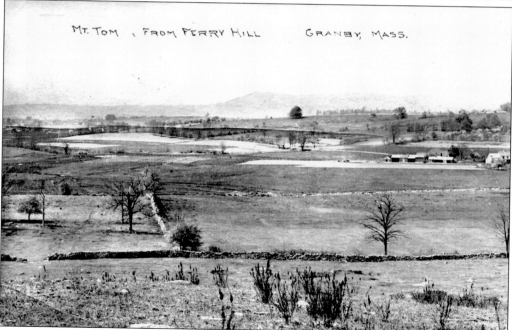

This postcard shows a pastoral view of Mount Tom from Ferry Hill. Note the open meadows and the stone walls that New England farmers used to bound their farms. Meadowcroft Farm can be seen in the distance along U.S. Route 202.

Know all Men by these Presents, That we

Jotham Clark Gideon Moody & Luther Ferry

of Granby in the County of Hampshire, and Commonwealth of Massachusetts, being a Committee appointed and authorised by the proprietors of the east Meeting-house in said Granby, to give Deeds of the Pews in said Meeting-house. By virtue of the power vested in us and also in consideration of the sum of *fifty six* Dollars to us paid before the ensealing hereof by *Elijah C. Ferry*

of said Granby, the receipt whereof we do hereby acknowledge, do hereby give, grant, bargain, sell and convey to *him* the said *Elijah C. Ferry*
his heirs and assigns forever all the right in and title to the following described Pew in said Meeting-house—(viz) *number fifty one on the lower floor*

To HAVE and to HOLD, the said Pew with all the privileges and appurtenances to *him* the said *Elijah C. Ferry*
his — heirs and assigns forever.

IN WITNESS WHEROF, we the said Committee have hereunto set our Hands and Seals this *first* day of *January* — in the year of our Lord, one thousand eight hundred and twenty *two*

Signed, Sealed and delivered
in presence of

Charles Ferry
Elihu Clark

Gideon Moody
Jotham. Clark
Luther Ferry

Early church members were encouraged to rent or buy pews in order to bolster church finances. This deed from the Church of Christ to Elijah C. Ferry "assigns forever all the right in and title to pew 51 on the lower floor." It is signed by Charles Ferry, Gideon Moody, Jothan Clark, and Luther Ferry. Their seals can be seen in the right-hand margin of the document. (Courtesy Church of Christ, Congregational.)

The Batchelor family, for whom Batchelor Brook is named, was prominent in 19th-century life in Granby. This portrait, from 1890, shows the family in one of the more informal poses of the time. They are, from left to right, as follows: (front row) Harry, Jen, unidentified, John, William, Susan, and David William; (back row) Sara, Bertha, and Lou.

This English-style house at 56 Aldrich Street, shown with the same Batchelor family seated in the yard, was built in the late 1700s. Levi Taylor, a partner and superintendent of the woolen mill in Granby Hollow, lived here until his death in 1849. Other people who lived in this house include John Batchelor and William and Jennie Batchelor.

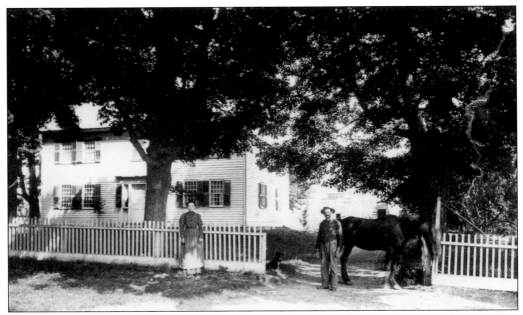

The Josiah Montague house, at 202 West Street, is shown on the Granby map of 1762. Before Granby built proper school buildings, classes were held in this house on the second floor. Joseph Skinner also owned this place and restored it to its Colonial style. Several generations of Montagues have lived there.

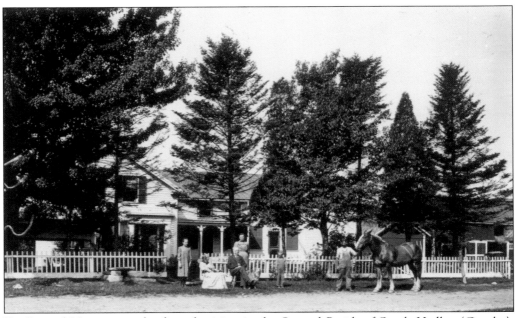

Dr. Samuel Vinton was the first physician in the Second Parish of South Hadley (Granby), practicing from 1762 until 1801. Vinton lived in this house at 1 Bittersweet Lane from 1762 until his death in 1801. This house was listed within South Hadley during the trouble over the dividing line between South Hadley and Granby.

This house was built on the site of Phins Hill Manor, Granby's present-day senior housing. The 12-room Phineas Smith House had a room accessed through one of the fireplaces, used to hide fleeing slaves on the Underground Railroad. The house was torn down in 1948. A 1929 newspaper clipping reads, "Gentlemen's Estate: One of the finest old colonial homes in Massachusetts, located in Granby on new highway from Holyoke to Belchertown. Built in 1793, elevation 1200 feet, on Phins Hill. View from the house one of the best in New England. Beautiful grounds and fine old shade trees. House contains 12 rooms. Living room 40 by 12 feet. Large stone fireplace, two other fireplaces on first floor. Old handmade hardware and paneling. Would serve as a boys' or girls' camp, private hospital, or clubhouse. Grounds would make wonderful golf course. Contains 100 acres with 150 fruit trees, fine trout stream. Will sell as much land as desired. Chance of a lifetime to buy a beautiful house. Call or write J. V. Malone, Granby, Mass. Tel 3—3."

The town common was used to protect livestock from raids and for social events, such as the traditional election day gathering, where citizens, after having voted, would meet for 'Lection Cake, to share news, and to debate the possible outcome of the election. The picture above shows Granby common lined with impressive sugar maples and great sycamore trees hugging U.S. Route 202. Their great overhanging branches obscured the highway, caused many accidents, and eventually had to be cut down. The picture below shows the common in the winter. The Granby Library can be seen to the right of the automobile. The Church of Christ is on the hill to the right.

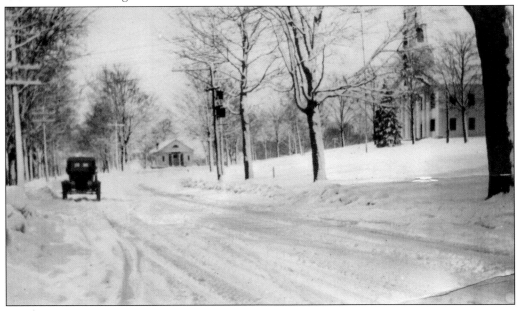

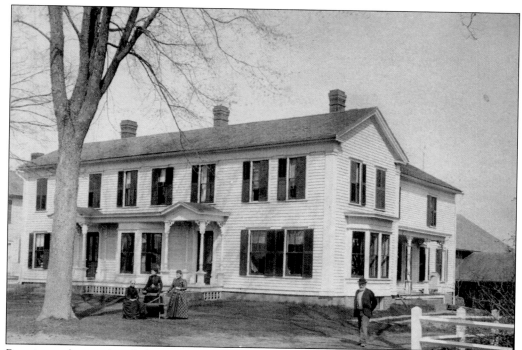

Prominent homes lined the common periphery. This photograph shows the Kellogg house, home to a prosperous farming family in Granby. At one time, they operated an inn on the north side of the house. According to Henry Dickenson, when the Church of Christ was under construction, "in front of where the Kellogg house now stands, Horace Cook and John Sikes were dispensing the liquor without which there could be no raising." The Kelloggs give their name to Kellogg Hall, formerly a school, now the Granby Town Hall.

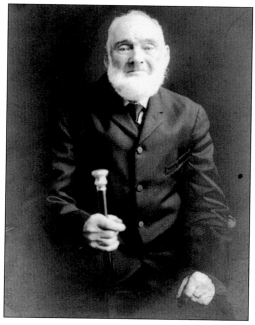

Charles Kellogg, shown here just before his death in 1915, holds the Boston Post Cane, given to him in 1913. The cane is traditionally given to the oldest citizen. The custom began when the publisher of the *Boston Post,* W.A. Grozier, bid successfully on an unclaimed consignment of gold-headed ebony canes in 1908. Grozier used the canes for publicity, distributing them to New England towns so they could be given to the oldest citizen by town officials.

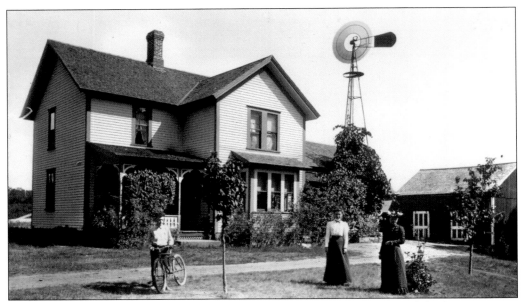

This house on the common, at 257 East State Street, was built on the site of the first parsonage in Granby Center *c.* 1880. The parsonage was struck by lightning and destroyed by fire. People who have lived in this house include Louise J. Smith, widow of Dr. C.B. Smith (who lost his life in the fire), Joseph H. Witt, and Herbert R. Durant. Elbert C. Aldrich, the last owner of this property, deeded it to the town. It is now used for town purposes, housing the Granby Council on Aging.

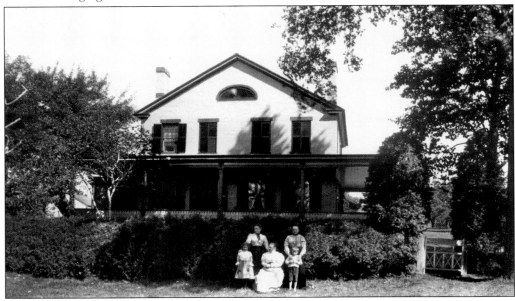

The house on the common at 4 Porter Street was built in 1830 as a parsonage for Rev. Joseph Knight. In the early 1900s, the Smith family occupied the house and developed the grounds behind it into a recreation area known as Wander Wood. The Smiths maintained the grounds for socials and town recreation, even hiring a recreation director during the summer to supervise games.

18

In sharp contrast to the formal photograph on page 13, this snapshot of William Batchelor, with his fish and cats at a shed along Batchelor Brook, more accurately depicts everyday life in Granby in the early 20th century.

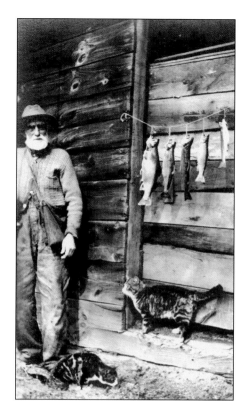

Everyday life in the early 1900s also included bathing the dog. Here, in a snapshot from the Kellogg family album, the Kellogg dog, Billiken, is enjoying his bath.

This house, at 291 East State Street, was probably built for Lt. John Moody when he bought 30 acres bordering Pea Brook. It is an old house, for we find Lt. John Moody on the map of 1762. The Moody family sold it to David Church. His son Rufus was born in 1806 and lived there until he died in 1898.

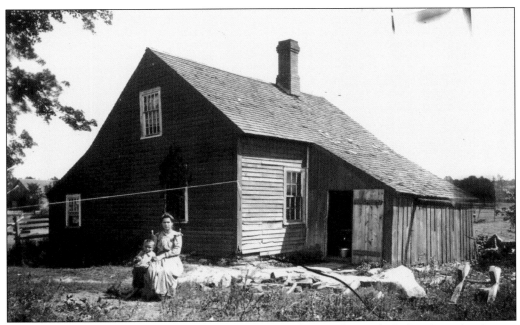

Dea. John Stebbins (son of Asaph Stebbins, an early Granby settler), lived in this house, formerly at 87 Taylor Street, one of the few early houses of this type built in Granby. Note the open door to a three-holer.

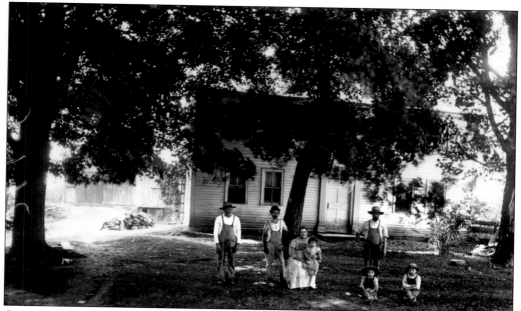

Capt. Augustus Clark built this house at 193 Amherst Street in 1817. The E. Thornton Clark house, at 388 East State Street, and this one are similarly constructed, the Thornton Clark house facing north and the Augustus Clark house facing east.

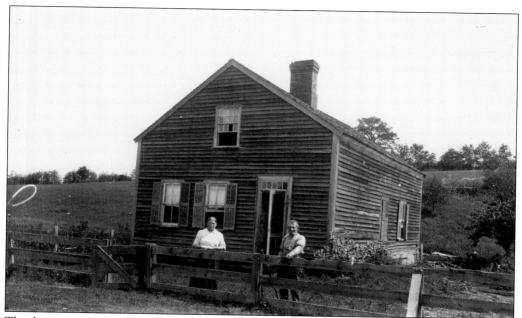

This house, at 70 Amherst Street, was built in 1824 for Horace Hatfield and his bride. More recent owners, the Mallars, have restored it where possible, tearing out the newer additions and finding that much of the old fireplace and oven still exist. People who have lived in this house are many and varied. Lorenzo Nash's diary mentions his hired man as a resident.

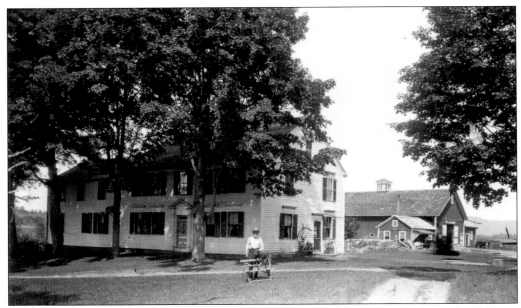

At 130 West Street is the Levi Smith house, built in the late 1700s. In the early 1800s, it functioned as an inn. Thereafter, the first floor of the west-side addition was used as a store, and a room over the store served as a select school. The Smiths who lived there were Levi I, Levi II, George R., and Rutherford H. The site was sold to Wilfred Constant in 1921.

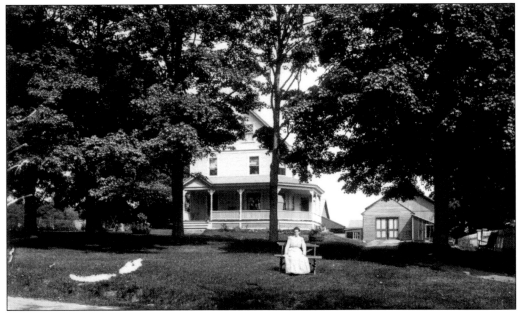

The house at 164 West Street was built on the site of the home of the third minister, Rev. Elijah Gridley. The home, which burned in 1898, was at one time a preparatory school for girls entering Mount Holyoke Seminary for Women in South Hadley. The first occupants of this house were the Guiel family.

Two

CHURCHES

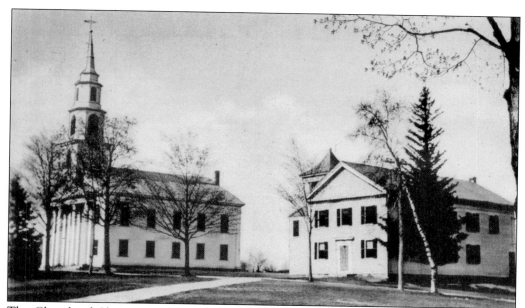

The Church of Christ, Congregational, and the parish house dominate the town common. (Courtesy Jeffrey Dwinell.)

Articles of agreement indented made and concluded this thirteenth day of Febuary in the year of our Lord one thousand Eight hundred and twenty one by and between Luther Carter of Monson county of Hampden and Elias Carter of Mendon county of Worcester and state of Massachusetts Gentlemen on one part and Eli Dickinson Esq Gideon Moody Gentlemen Jotham Clark William Snow Wait Still Dickinson John Preston Luther Frey Aron Carver Ariel Taylor Elihu Clark Nathan Smith Jr Israel Clark Jr and Benjamin Witt all of Granby county of Hampshire state of Massachusetts being a committy of the subscribers for building a Meeting House in said Granby on the other part as follows first the said Luther Carter & Elias Carter for the consideration hereafter mentioned doe for them selves their heirs Executors and administrators covenant promise and agree to and with the said Eli Dickinson Esq Gideon Moody Jotham Clark William Snow Wait Still Dickinson John Preston Luther Frey Aron Carver Ariel Taylor Elihu Clark Nathan Smith Jr Israel Clark Jr and Benjamin Witt their Executors and administrators that they the said Luther & Elias Carters shall and will on or before the first day of November next will and substantially Erect build Set up and compleatly finish in Granby aforesaid a little North of Mr John Montagues dwelling House a Meeting House for publick worship according to the Draft or scheme a grida pon and subscribed by the partys to this instrument of the dimentions following + (SS)

In 1820, the East Parish community engaged architect Elias Carter to "erect, build, sit up, and compleatly finish in Granby aforesaid a little North of Mr. John Montagues dwelling house a Meeting House for publick worship . . . good and as hily finished as Mendon Meeting House . . . to be finished with a Steeple Equal to the meeting Hous in Mendon with a Lightning rod affixed to the Steeple [for] the sum of four thousand Eight hundred Dollars." (Courtesy Church of Christ, Congregational.)

The church was built on land donated by John Montague and was dedicated in 1820. It still stands today as it did then, so prominent on the New England landscape that planes from nearby Westover Air Reserve Base use its steeple as a reference for landing. (Photograph by Rev. Melvin Williams; courtesy Church of Christ, Congregational.)

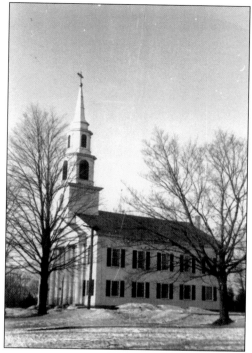

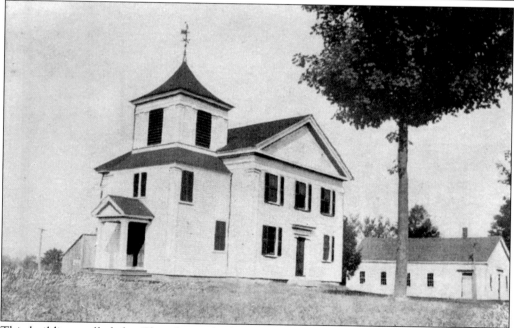

This building, called the Chapel, was built next to the church in 1841 during the tenure of Rev. James Bates to be used as a high school and lecture hall. Until 1890, the high school occupied it. Today, it is known as the Parish House and is used as a meeting place for church and town events and organizations. The Firemen's Association Roast Beef Dinner and the Lion's Club Pancake Breakfast are but two of the sumptuous feasts held there every year.

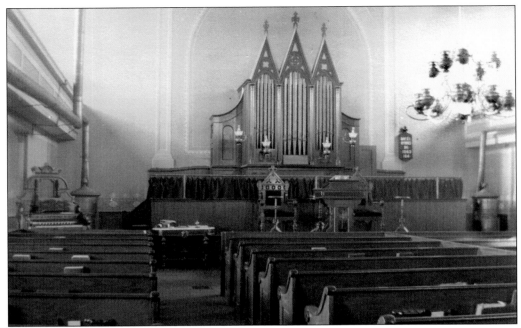

The photograph above shows the interior of the Church of Christ before 1912. According to tradition, the original pulpit, designed and built by Elias Carter in 1820, was replaced in 1878 to make way for the first pipe organ, at which time many more aspects of the church were changed to reflect current architectural taste. In 1912, Annette Warner, designer and art historian, redesigned the church interior to reflect the original. The photograph below shows the result, including the Estey organ, made in Brattleboro, Vermont, and donated by Charles W. Ferry. On April 20, 1913, Rev. Robert C. Bell dedicated the renovated church and the organ "to the beauty and strength of the worship of God's earthly house . . . to the uses of the Holy Spirit, the honor of our Lord Jesus Christ, and the bringing in of the glorious Kingdom of God."

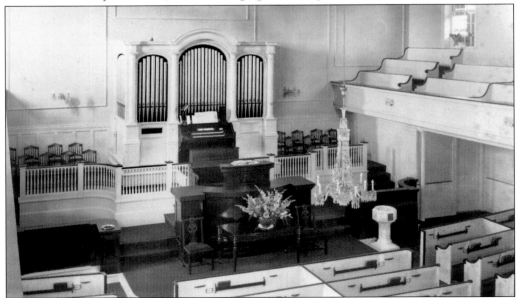

Rev. Henry Davis, shown here with his family, served the Church of Christ from 1875 to 1878.

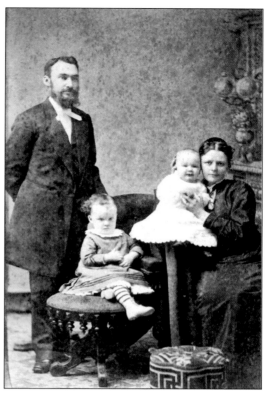

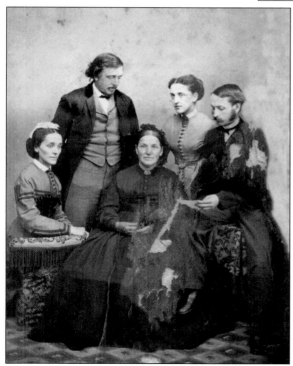

Dr. Cyrus B. Smith (back row, left) and his wife (front row, left) are pictured with Smith's mother-in-law, Mrs. Hulbert (center), and Alfred Ray and his wife. Smith served as a surgeon during the Civil War. He was church organist, choir director, and town representative in the Great and General Court. He practiced in Granby until 1879, when he was killed by a bolt of lightning, which struck his home at 257 State Street.

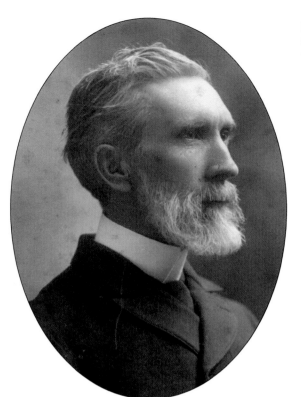

Rev. Robert Caird Bell served the
Granby Church of Christ during the
time of its renovation in 1913.

Rev. Arthur Weil guided
the Granby congregation
through World War II,
serving from 1942 to 1947.

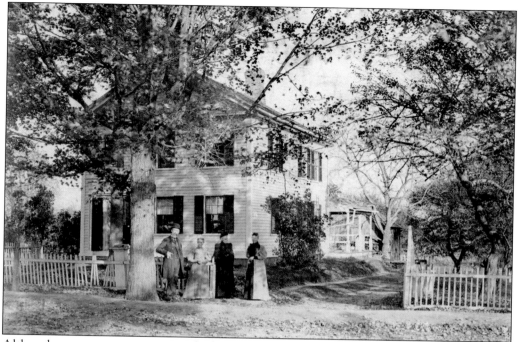

Although many parsonages were built to house Church of Christ ministers, the present parsonage at 3 Center Street was built in 1840, and Rev. James Bates was the first minister to live there. This photograph by Alva Howes, a prominent early photographer of New England homes, shows the parsonage c. 1900, when Reverend Bell and his family resided there. Standing in front of the house are Bell, Bell's wife, Mrs. Smith, and Catherine Bell.

Christian Endeavor Week
Granby, Mass., Feb. 1-8, 1914.

Sunday Feb.1–Christian Endeavor Day. Sermon by the pastor. Union Service in Church in the evening.

Monday Feb.2–Recruiting Social in the Chapel. An evening of recreation.

Wednesday Feb.4–Efficiency Day. Address at 7.30 by M. F. Childs of Amherst College. Singing by visiting quartette.

Thursday Feb.5–Church Day. Service at 7.30. Subject : Our Expectations from God.

Friday Feb.6–United Society Day. Entertainment. Mock Trial in Kellogg Hall at 8 o'clock.

Sunday Feb.8–Decision Day. Special Service in the Church at 7.

The United Society of Christian Endeavor, founded in 1881 by Rev. Dr. Francis Edward Clark, sought to interest young people in the church. The movement grew rapidly in the late 19th and early 20th centuries until nearly every mainstream Protestant church had a Christian Endeavor Society. This card shows the program for Christian Endeavor Week, celebrated at the Church of Christ in 1914.

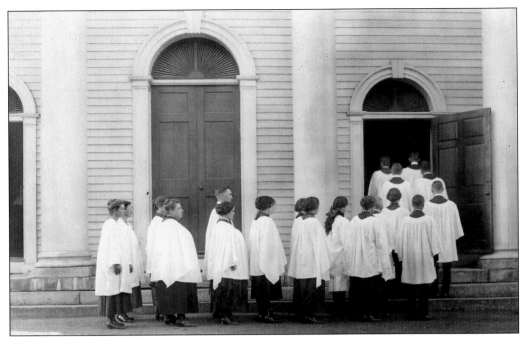

Photographer William C. Hart captured images of this Christian Endeavor Week celebration in 1914 at the Granby Church of Christ. Above we see the choir processing into the church; below, the choir is shown in the chancel. Only some of the choir members are identified. They include the following: (sopranos) Evelyn, Miss Peck, Dorothy, Della, Lucy, and Mrs. Smith; (altos) Carrie, Miss B., Jennie, Miss Cobb, and Margaret; (tenors) J.A.S., Ernie, and Paul; (basses) C.H. Gold, R. Smith, and Doug.

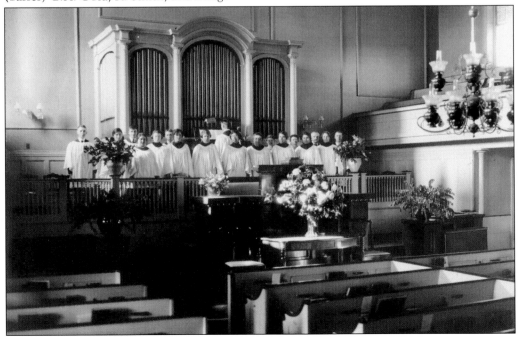

Harvest Dinner
Granby, Mass.

Served by the Ladies of the
Congregational Church in
the Chapel

Wed. Sept. 29, 1915
12 to 9 P. M.

CHICKEN PIE
Vegetables, Relishes, Pies, Fruits, Coffee, Tea, Etc.

Canned Fruits, Vegetables and Confectionery for Sale

Special attention paid to Automobile and Carriage Parties

Price, 50c.

"Mrs. Briggs of the Poultry Yard"
A Comedy in Three Acts

Kellogg Hall, 8.15 p. m.

Tickets, 25c. Children, 15c.

This poster from one of the early Church of Christ Chicken Pie Suppers, then known as the Harvest Dinner, makes us long for the old days when dinner only cost 50¢. For more than 100 years, people from all over Massachusetts have thronged to the annual Chicken Pie Supper, held by he Church of Christ Woman's Guild. (Courtesy Darcy Henry.)

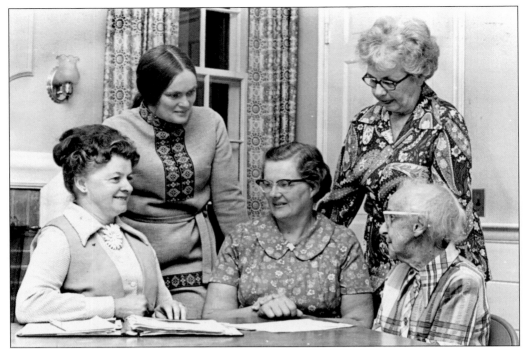

Women of the Church of Christ plan the annual Chicken Pie Supper. They are, from left to right, as follows: (front row) Maudetta Taylor, Phebe Nash, and Myrtie Hobart; (back row) Joan Wyanski and Muriel Randall.

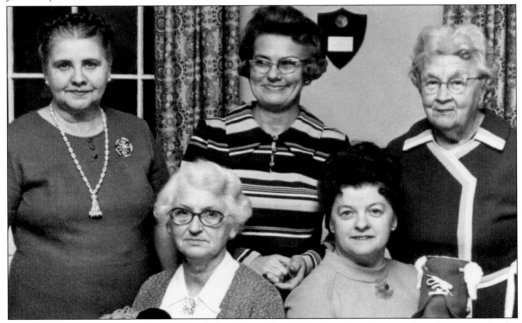

Members of the Woman's Guild of the Church of Christ show items they have made for the Christmas Fair. They are, from left to right, as follows: (front row) Dorothy Dressel and Maudetta Taylor; (back row) Ann Clark, unidentified, and Gertrude Taylor.

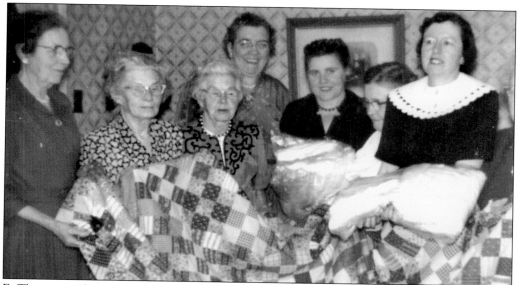

E. Thornton Clark's mother, a longtime, vital member of the church, received a quilt made by ladies of the church for her birthday in 1959. Pictured are, from left to right, ? Mathias, ? Clark, Myra Scott, Alice Nutting Thayer, Ann Clark, Helena Galusha, and Virginia Howland. (Courtesy Darcy Henry.)

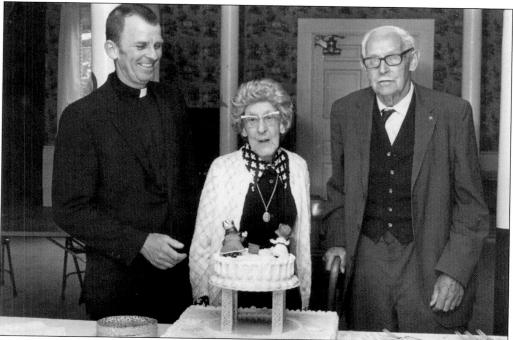

Myrtle Easton Hobart and her brother Wilbur Easton were honored in 1975 for more than 40 years of service to the Church of Christ. Wilbur Easton was the treasurer for 22 years, and Myrtle assisted with bookkeeping. The Easton family has been active in the Church of Christ for more than 100 years. Shown in this celebration picture are Rev. Richard Wyanski, Myrtle Hobart, and Wilbur Easton. (Courtesy Darcy Henry.)

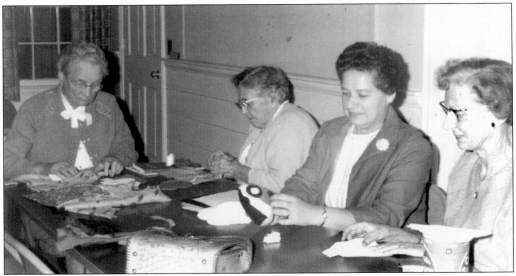

Ladies of the Woman's Guild prepare for their annual Christmas Bazaar in December 1969. From left to right are Gertrude Galusha, Helena Galusha, unidentified, and Ruth Mitchell. (Courtesy Darcy Henry.)

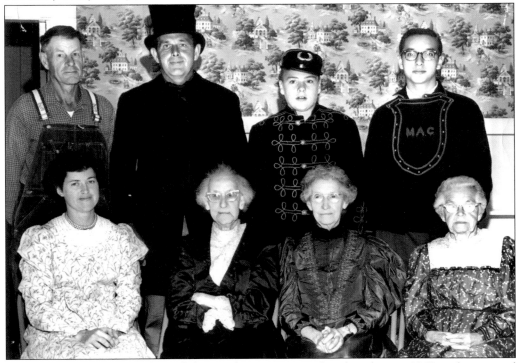

The Church of Christ celebrated the 200th anniversary of its founding in 1962 and presented a tableau tracing the church's history. These members of the cast are, from left to right, as follows: (front row) Beverly Galusha, Myrtie E. Hobart, Winifred Fiske, and Myra C. (Mrs. John H.) Scott; (back row) E. Thornton Clark, William DeWitt, unidentified, and unidentified. (Courtesy Church of Christ.)

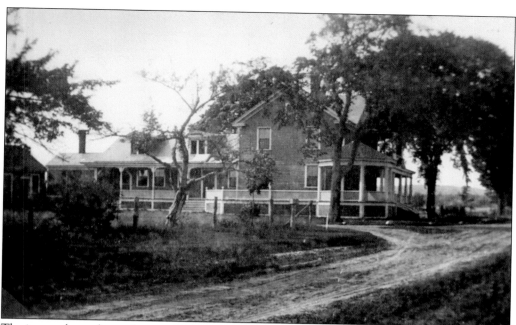

The image above shows the summer home of Rev. Fr. Charles E. Crevier, pastor of Precious Blood Church in Holyoke, who donated the home, along with a large tract of land bordering on Forge Pond, to the Franciscan Order for the purpose of building a convent. On September 25, 1926, a charter granted the Franciscan Minor Conventual Association of Granby permission to build, and construction began under the direction of Rev. Fr. Hyacinth M. Fudzinski, the first minister provincial and founder of St. Anthony's Province. The postcard below shows the first seminary building. The three-storied building was completed in 1927 and was built of Quincy granite. (Courtesy St. Hyacinth Seminary.)

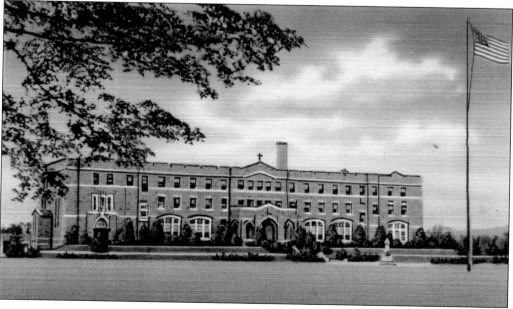

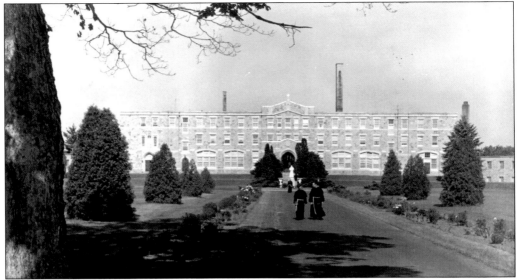

Franciscan Friars stroll the peaceful grounds of St. Hyacinth Seminary in Granby. For 75 years, the Franciscan Fathers and Friars took a vital interest in Granby, participating in community activities, cooperating in ecumenical endeavors, and lending the use of their beautiful building and grounds to members of the community. St. Hyacinth Seminary and grounds were sold in 2002. (Courtesy Darcy Henry.)

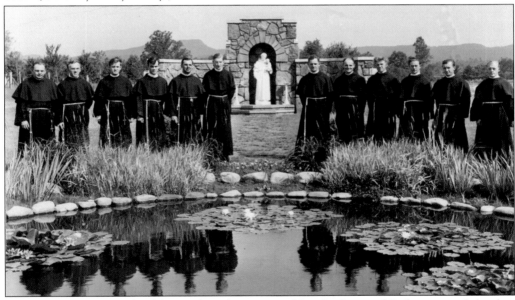

Franciscan Friars line the lily pond at the grotto of St. Anthony of Padua, one of the first members of the Order of Friars Minor and a contemporary of St. Francis of Assisi. Born in Lisbon in 1195, he was reported to be blessed with the Gift of Miracles. St. Anthony of Padua was engaged by St. Francis of Assisi to teach theology to the brethren but was also a gifted musician. The friars of St. Hyacinth followed in his steps, forming a singing group in the 1960s called the Singing Friars, who performed throughout western Massachusetts. (Courtesy St. Hyacinth Seminary.)

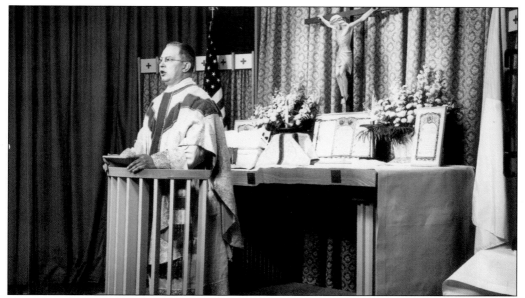

The Very Reverend Father Theophilus Kujawa, Order of Friars Minor, Conv., guardian at St. Hyacinth Seminary, speaks during Mass in the chapel. The chapel and seminary featured many beautiful antiquities, including an altar imported from the Church of St. Francis of Assisi in Italy. (Courtesy St. Hyacinth Seminary.)

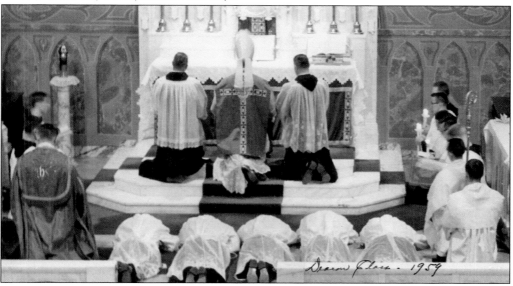

An ordination ceremony took place at St. Hyacinth Seminary on December 29, 1959. Five Franciscan Friars were ordained to the Diaconate, and one received minor orders. Bishop Christopher J. Weldon and the Very Reverend George Roskwitalisk, Order of Friars Minor, Conv., (Minister Provincial of St. Anthony of Padua Province) ordained the following: Rev. Roman Chwaliszewski, Order of Friars Minor, Conv.; Rev. Ronald Sermak, Order of Friars Minor, Conv.; Rev. Leon Kropiewnicki, Order of Friars Minor, Conv.; Rev. Norbert Giermek, Order of Friars Minor, Conv.; Rev. David Stopyra, Order of Friars Minor, Conv.; and Rev. Robert Plociennik, Order of Friars Minor, Conv. (Courtesy St. Hyacinth Seminary.)

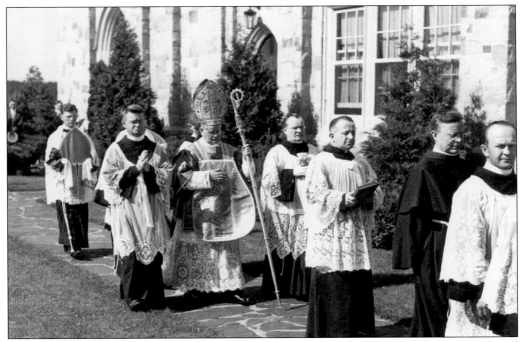

Bishop Thomas M. O'Leary of Springfield is shown leaving St. Hyacinth Seminary Chapel after ordaining a class of four young men into the priesthood on June 21, 1937. (Courtesy St. Hyacinth Seminary.)

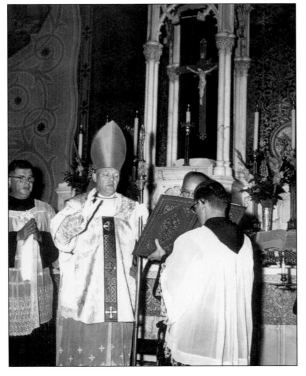

Bishop Christopher J. Weldon of the diocese of Springfield celebrates Mass in the chapel. (Courtesy St. Hyacinth Seminary.)

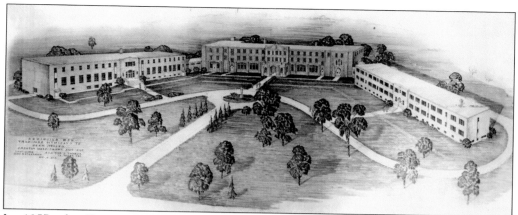

In 1957, the Franciscan Order reorganized its educational facilities, and St. Hyacinth became a four-year liberal arts college, able to confer baccalaureate degrees accredited by the Massachusetts Department of Education. Thus began an extensive building program in which a faculty building was completed in 1960, a residence for maintenance personnel in 1962, and, in 1965, the Father Kolbe Memorial Library and Administration Building, with stacks accommodating more than 150,000 volumes, reading and reference rooms, a seminar room, a press room, visual aid equipment, and administrative facilities. The image above shows an artist's conception of the project. The image below shows the project under construction. (Courtesy St. Hyacinth Seminary.)

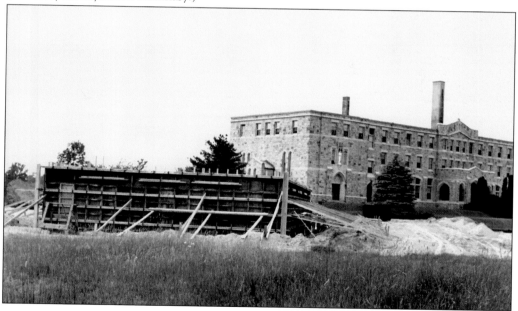

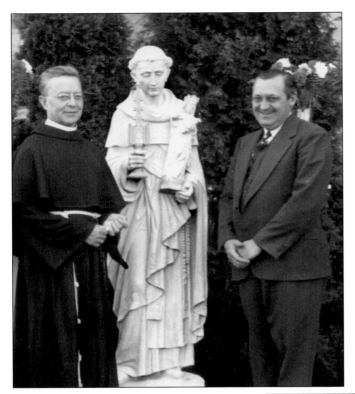

In 1935, noted naturalist and conservationist Burlingham Schurr of Granby established a museum of natural history in the seminary library. Burlingham Schurr is shown here on the right, receiving thanks from an administrator in behalf of St. Hyacinth Seminary. (Courtesy St. Hyacinth Seminary.)

Granby naturalist Burlingham Schurr presents an honorable mention for excellence in studies in natural science during graduation ceremonies at St. Hyacinth Seminary. (Courtesy St. Hyacinth Seminary.)

The Friars of St. Hyacinth Seminary have always played a vital role in area communities. The photograph above shows seminarians during a pageant depicting the Polish Millennium of Christianity. Entitled *One Thousand Years of Polish History and Culture in Tableau*, the pageant was presented at Cathedral High School Auditorium in Springfield, Massachusetts, on Sunday, May 22, 1960. The photograph below emphasizes the role they played during World War II, when they received the Army Air Forces Certificate of Honorable Service for loyal and faithful volunteer service from Col. Stewart W. Towle Jr., commanding officer of Mitchel Field in New York. (Courtesy St. Hyacinth Seminary.)

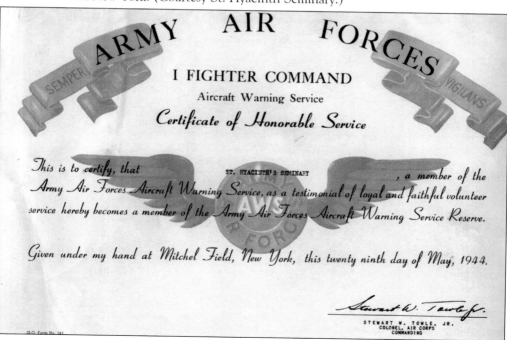

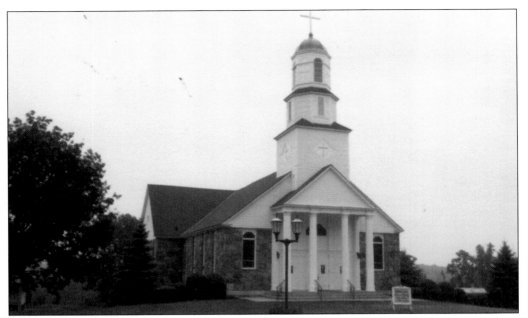

At the end of the 19th century and beginning of the 20th, with the influx of immigrants from Europe to New England, the number of Catholic families in Granby grew significantly, creating a need for a Catholic church. Thus was born the Welcome Society, whose long-range goal was to erect a Catholic church in Granby. The fruit of their labors, in lawn parties, socials, dances, card parties, and suppers, is shown in the photograph above of Immaculate Heart of Mary Church, constructed on the second-highest point on Granby common, facing the Church of Christ. Through the years, a spirit of ecumenism has bonded the Protestant and Catholic congregations. The Welcome Society officers stand proudly in the photograph below. They are, from left to right, Phil Giraux, Agnes Giraux, Josephine Bissell, and Eugene Bissell. (Courtesy Immaculate Heart of Mary Church.)

Building Immaculate Heart of Mary Church was a total community undertaking. Granby residents of all faiths donated stones from their land and stone walls. Men donated their time and backs to haul, split, and place the stones and to construct the building. In this photograph, stonemason Anthony Rufo and his son Paul lift and place the stones just right. Ovila J. Bourbonnais drew up and freely executed the plans. (Courtesy Immaculate Heart of Mary Church.)

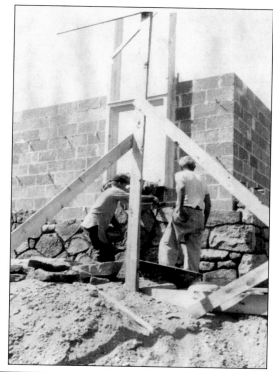

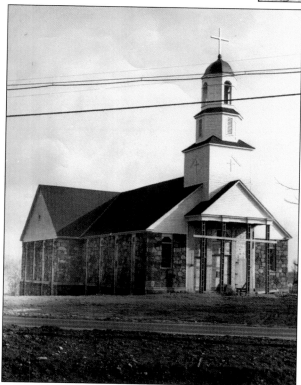

This photograph shows the church nearing completion, built literally on the rock of Granby, from foundation to roof. Upon its completion in 1951, the workmen were feted with a turkey dinner given by Oliva J. Bourbonnais and cooked by his wife. The stainless-steel cross atop the spire was given by Alphonse Turcotte. (Courtesy Immaculate Heart of Mary Church.)

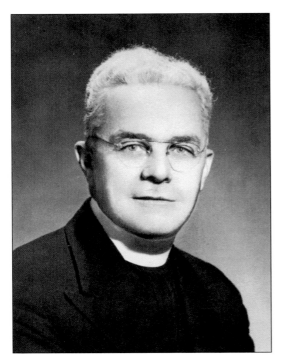

This photograph shows Rev. Fr. Andrew F. Sullivan, who celebrated the first Mass in the church on Christmas Day 1950, with the interior only partially completed. In May 1951, the completed church was blessed and dedicated by the Most Reverend Christopher J. Weldon, bishop of the Springfield Diocese. By 1961, the basement was converted to accommodate the growing parish. (Courtesy Immaculate Heart of Mary Church.)

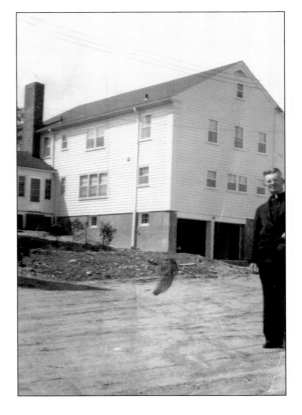

Groundbreaking for the Immaculate Heart of Mary rectory next to the new church began in 1952 and was completed in 1953. Here, Rev. Fr. Andrew F. Sullivan stands next to the nearly completed building. Fr. George J. Friel was the first resident pastor. (Courtesy Immaculate Heart of Mary Church.)

Rev. Fr. Andrew F. Sullivan celebrated the first Mass in Immaculate Heart of Mary Church on Christmas Day 1950. Note the original wall covering, which was replaced during later renovations.

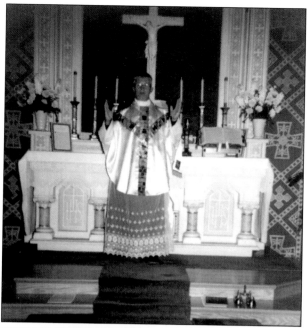

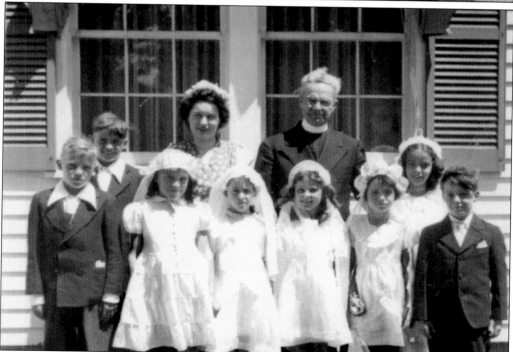

The first First Communion class for the new Immaculate Heart of Mary Church poses for the camera. Included in the photograph are Patricia O'Connell, Robert Maillous, Betty Miller, Donald Desormier, Carol Mikolajcik, Nicholas White, Paul Desroches, Leonard Mikolajcik, and William Miller. Rev. Fr. Andrew F. Sullivan stands in the back row. (Courtesy Immaculate Heart of Mary Church.)

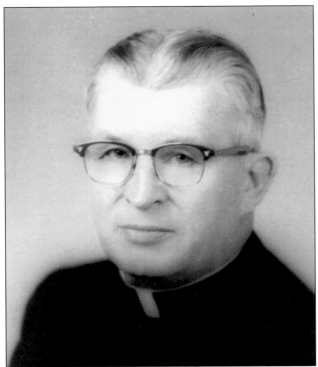

Rev. Fr. George J. Friel became Immaculate Heart of Mary's first resident pastor in December 1951. For two years, only one Mass was celebrated on Sundays. By 1961 the congregation had grown so much that two priests from St. Hyacinth Seminary assisted Father Friel in celebrating six Masses each Sunday. (Courtesy Immaculate Heart of Mary Church.)

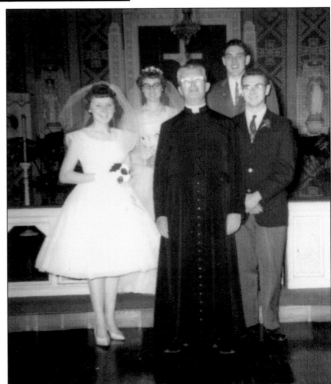

Father Friel stands with the first parishioners to celebrate the Sacrament of Marriage at Immaculate Heart of Mary Church. (Courtesy Immaculate Heart of Mary Church.)

For more than 30 years, Rev. Fr. John J. Shea has been addressing the needs of the Immaculate Heart of Mary community. Currently, the parish has about 2,500 members. Father Shea graduated from St. Jerome's High School in Holyoke, Massachusetts, and earned his doctorate in canon law from Gregorian Institute in Rome. He was 82 in March 2002 and has no plans to retire. (Courtesy Immaculate Heart of Mary Church.)

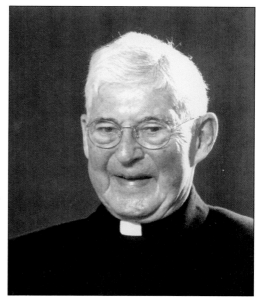

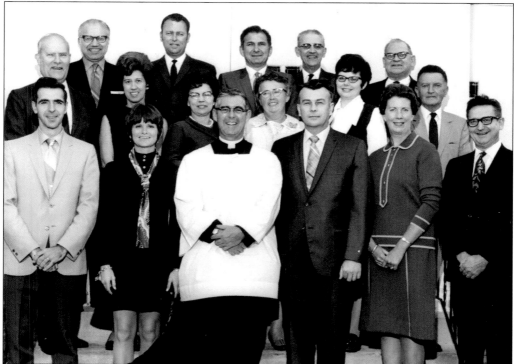

Fr. John Shea poses with the first Parish Council. They are, from left to right, as follows: (front row) Earnest Archambault, Virginia Snopek, Fr. John Shea, Robert Sheehan, Elizabeth Gillespie, and Frank LaFlamme; (middle row) Rene Fortier, Sally Carrington, Adrienne Roy, Marguerite Bombardier, Lorraine Carriveau, and John McCool; (back row) unidentified, Arthur Lempke, Chester Rutkowski, Wilfred Roy, and James Concannon. (Courtesy Immaculate Heart of Mary Church.)

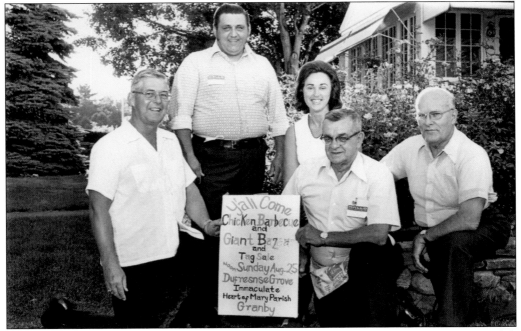

Immaculate Heart of Mary Catholic Church plans a chicken barbecue in the 1980s. From left to right are the following: (front row) Rev. Fr. John Shea, Henry Lafontaine (holding sign), and Rene Fortier; (back row) Walter Woznicki and Shirley Clapin. (Courtesy Immaculate Heart of Mary Church.)

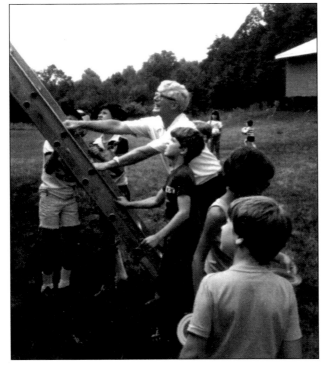

Vacation Bible School has always been a large part of Immaculate Heart of Mary's summer fun. In typical fashion, Father Shea helps the children with their activities, here raising a ladder to the roof of the pavilion so the pavilion can be decorated.

Three

FARMING

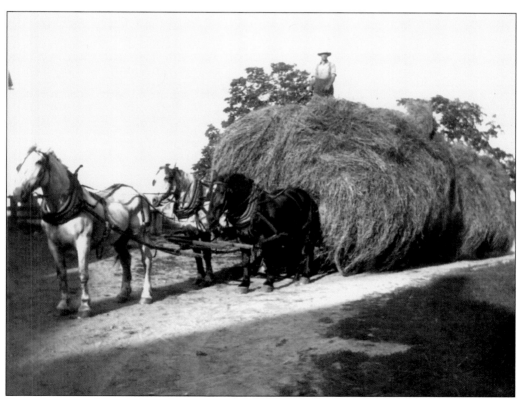

From the time of Granby's settlement until the early 1940s, farming was the principal source of income in the area. This *c*. 1940 photograph shows Charlie Lyman bringing in two wagons of hay, one hitched behind the other, at the Lyman Farm at 7 Carver Street.

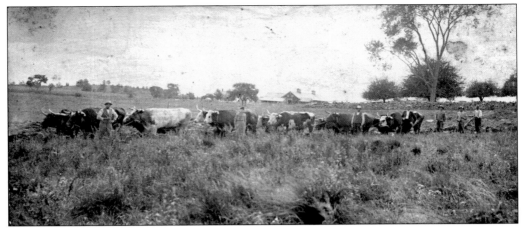

In 1771, 66 horses, 102 oxen, 184 cattle, 532 sheep, and 117 swine were listed on the census in Granby. Oxen, not horses, were used as draft animals. This photograph, taken c. 1890, shows six yoke of oxen plowing a field, probably at the Clark farm. In 1750, Israel Clark moved from South Hadley to what is now Batchelor Street in Granby.

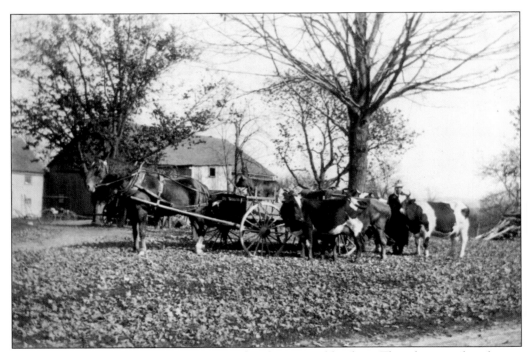

Horses were used for transportation, oxen for plowing and hauling. This photograph, taken at the E. Thornton Clark farm c. 1951, shows a horse hitched to a wagon, tethered to which are several cows and heifers, probably to be taken to market.

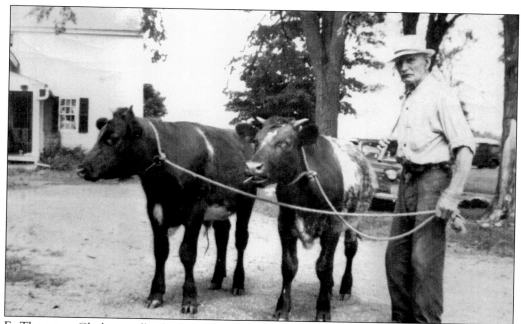

E. Thornton Clark proudly displays his oxen at his farm in 1951. Farmers from Granby and surrounding towns still participate in raising oxen—not for farm use, but for entering in annual ox-pulling contests at local fairs, one of which is Charter Day, held in Granby each year.

This photograph shows the Stiles Farm at 55 Ferry Hill Road in December 1945. The exact age of this farmhouse is unknown, but it was built by one of the Ferry brothers, original settlers of Granby. (Courtesy Darcy Henry.)

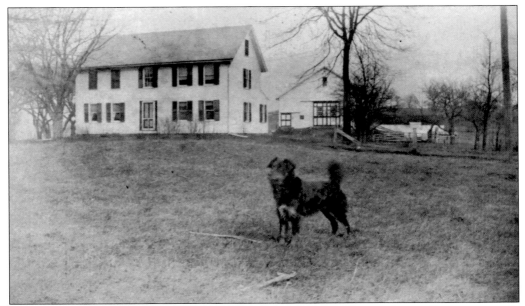

This photograph shows the Benson Farm, located at the end of Barton Street. Farmers not only tended their holdings but cared for town roads. According to Granby resident George Galusha, "In Summer, Deacon Walter Benson would come with his crawler tractor and pull the town road scraper behind and level the road out. He was the deacon of the church. We always called him Deacon."

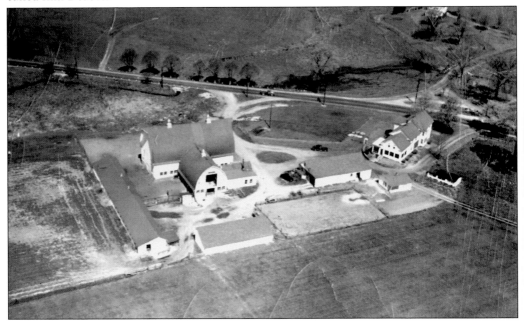

This aerial photograph shows Meadowcroft Farm on West State Street in 1949. Adrian Howard Hatch and Edith Hatch owned the farm, prominent in the nation's dairy history. At one time, it was listed as the largest and most prosperous dairy farm in Massachusetts and was often featured at the Eastern States Exposition as an example of excellence. (Courtesy Viola Lyman Hatch.)

The Fuller Farm was located at the corner of Pleasant Street and U.S. Route 202, also known as Five Corners. In this photograph, taken in 1928, young Charlie Lyman uses a yoke of oxen for transportation. (Courtesy Viola Lyman Hatch.)

In this 1918 photograph, Charles and Lawrence Lyman pose with a prize bull at the Lyman Farm on Carver Street. (Courtesy Viola Lyman Hatch.)

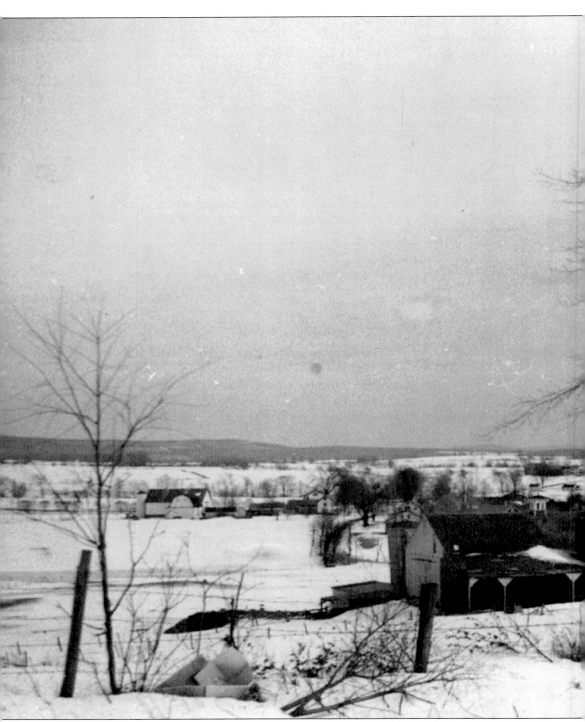

This photograph illustrates the prominence of farming in Granby. It was taken in the 1940s from the top of Cold Hill, looking down on Breezy Acres Farm, owned by Robert and Viola Hatch on Pleasant Street. The hills roll first to John Scott's farm in the immediate background, then

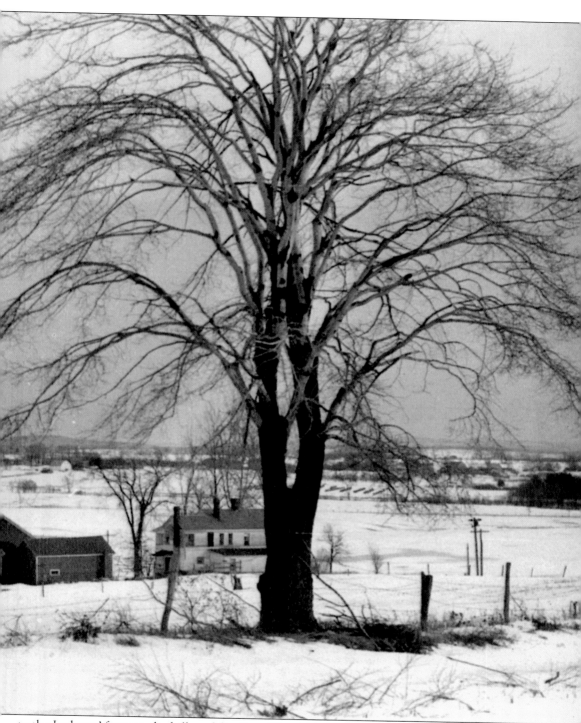

to the Inghams' farm on the hill, and finally to Harnish's farm in the far background. (Courtesy Viola Lyman Hatch.)

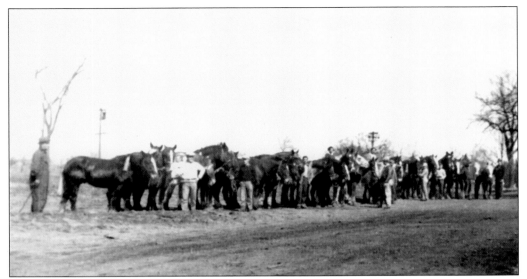

In the 1930s, green horses were walked, three to a person, from the train in Holyoke, across the South Hadley Falls bridge, and up U.S. Route 202 to the Hatch Farm, where they were broken and resold. This photograph shows a line of horses, fresh from the train, being led into Granby. Note the horses' heavy statures. By this time, farmers used horses as draft animals, though some oxen were still used for that purpose. (Courtesy Viola Lyman Hatch.)

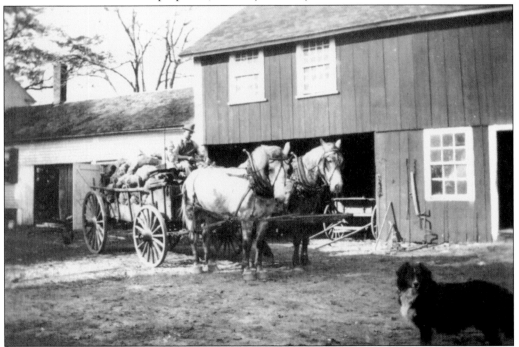

This photograph shows Charlie Lyman, escorted by the family dog, transporting potatoes to market from the Lyman Farm on Carver Street in the 1930s. The Lymans used horses for transportation and working the farm well into the 1950s, when they finally purchased their first truck. (Courtesy Viola Lyman Hatch.)

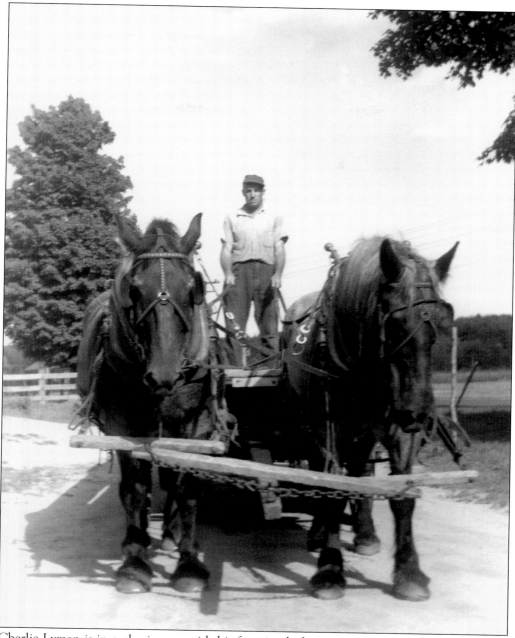

Charlie Lyman is in a classic pose with his favorite draft team at the Lyman Farm on Carver Street. (Courtesy Viola Lyman Hatch.)

Transportation varied throughout one's lifetime on the farm. Here Dwight, Susan, and Carol Hatch use the buggy in the spring of 1946 at Breezy Acres Farm on Pleasant Street. (Courtesy Viola Lyman Hatch.)

In 1951, Nancy and Norman Hatch graduated to the larger horse-drawn wagon at Breezy Acres Farm at 17 Pleasant Street. (Courtesy Viola Lyman Hatch.)

If we can't get into the truck, maybe we can ride on top! Norman and Nancy Hatch contemplate their choices at Breezy Acres Farm on Pleasant Street in 1951. (Courtesy Viola Lyman Hatch.)

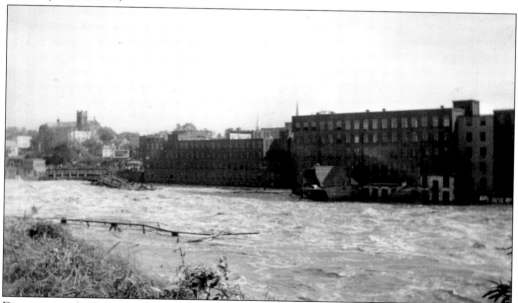

Disaster struck New England on September 21, 1938. This photograph shows the Chicopee Bridge after it collapsed. Granby resident George Galusha remembers, "I was attending the Eastern States Exposition. There was no school that day because it had been raining. [When] the hurricane hit, the grandstand collapsed with people in it. I remember going by the 4-H cattle tent, and it went up in the air. . . . We got in the car and we were going across Memorial Bridge and it was swaying." (Courtesy Viola Lyman Hatch.)

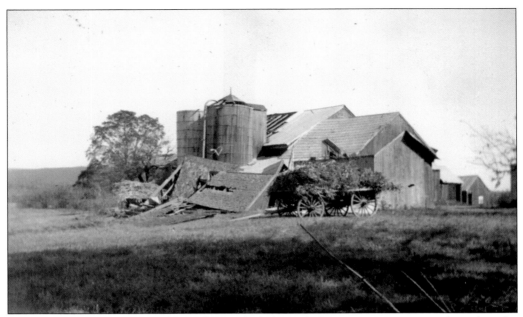

M.E. Old's barn, above, and Dwight Taylor's barn, below, were common sights after the Hurricane of 1938. Farmer George Galusha remembers, "Two maple trees were on the house, a maple tree had squashed down the garage, the doors on the barn were missing, we had no electric power for two weeks. They milked by hand, they rigged up something with the tractor on the well to run the pump. All power lines were down. I remember voluntary crews were out the next morning cutting trees. They would do it by hand, cross-cut saw and axes." (Courtesy Viola Lyman Hatch.)

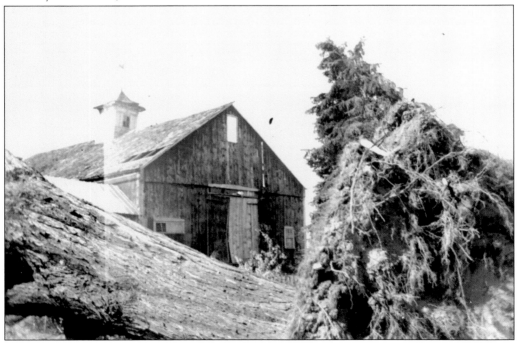

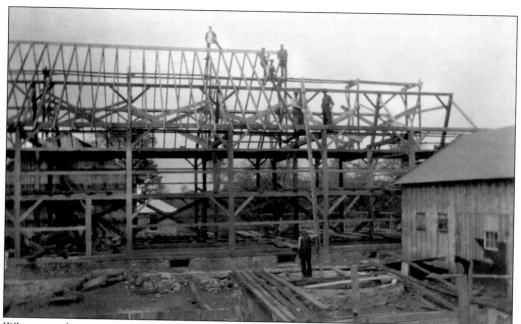

Whenever disaster struck, neighbor helped neighbor to rebuild. This photograph shows the barn raising to rebuild the Lyman barn after it burned in 1922. (Courtesy Viola Lyman Hatch.)

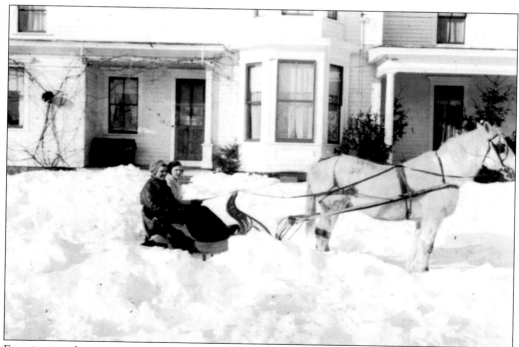

Farming in the winter was more difficult, but some times were made more enjoyable by a good snowfall. Here Viola Lyman (left) and Rachel Randall are about to enjoy a sleigh ride in January 1936. (Courtesy Viola Lyman Hatch.)

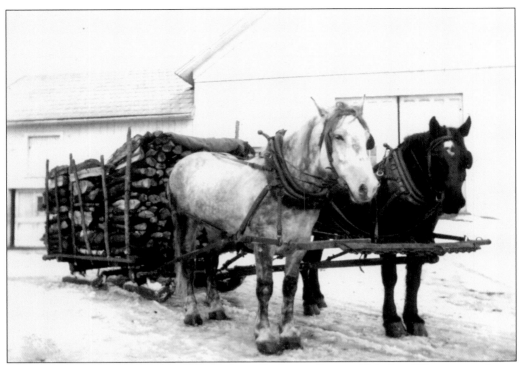

"Farming in the wintertime was difficult," recalls farmer George Galusha. "The water tub was frozen and everything was hard. A lot more chores. Snow showed up in the doorways everywhere. Haul the equipment out. I never got frostbit. The stable was warm, where the livestock were, it was probably 50 degrees. Not heated, but the animals kept it warm." The photograph above shows the Lyman's wood loaded on a sleigh in February 1935. The photograph below shows Clarence Lyman hauling cow corn along Carver Street. In the background is Lena Eastman's home at the corner of Carver and Chicopee Streets. (Courtesy Viola Lyman Hatch.)

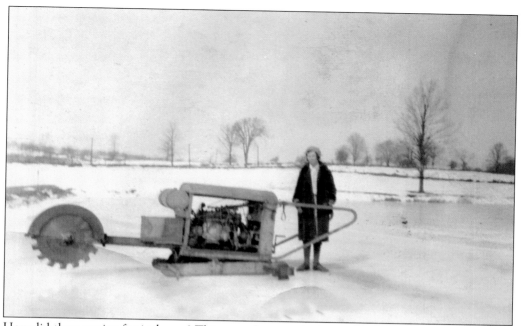

How did they cut ice for iceboxes? This rare photograph shows an ice cutter on Carver Pond. Viola Lyman stands beside it.

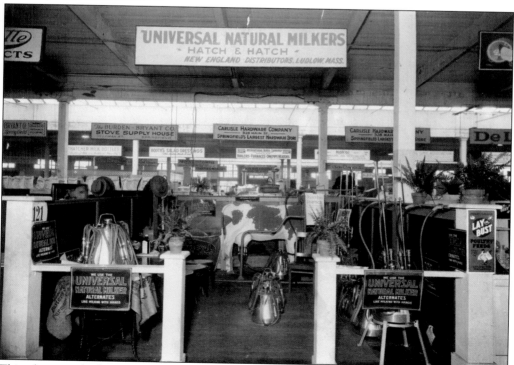

This photograph shows a Universal Natural Milkers display at the Eastern States Exposition. Hatch & Hatch were the New England distributors in Ludlow, Massachusetts. Meadowcroft Farm was in Granby, but the distributorship was based in the adjacent town of Ludlow.

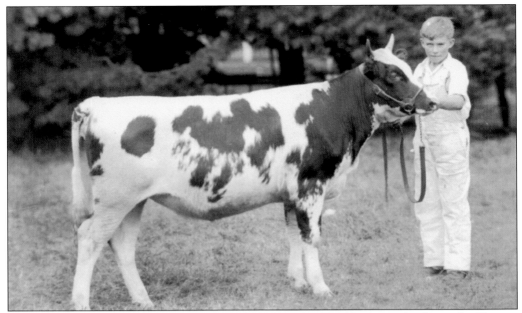

Young Adrian Robert L. Hatch is seen with his 4-H Junior Champion heifer at the Eastern States Exposition in 1932.

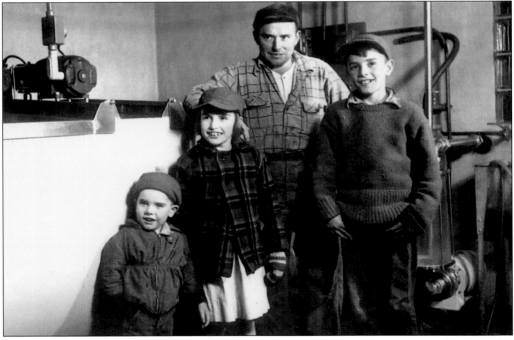

Breezy Acres Farm was one of the few dairies to have a milking parlor. Instead of milking the herd while they stood in their stalls, six cows at a time were brought into a clean parlor to be milked and then returned to their stalls. This Hatch family portrait was taken in the only milking parlor in Granby, at 19 Pleasant Street, when it became operational c. 1953. From left to right are Norman, Carol, Robert, and Dwight Hatch.

Four

BEYOND FARMING

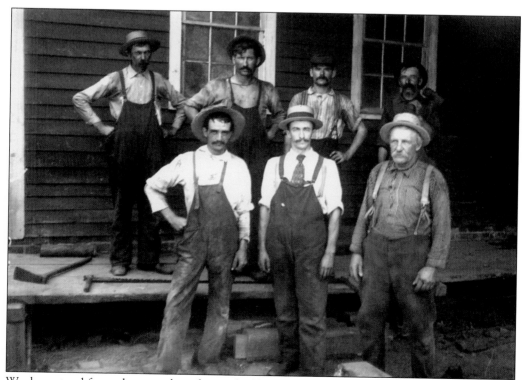

Workers stand for a photograph in front of Aldrich Mill *c.* 1900.

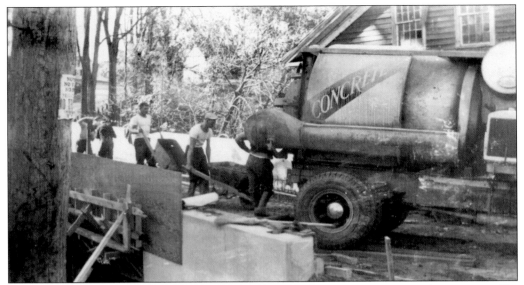

Those in Granby who could not make a living farming ran taverns, cottage industries, or mills. The Aldrich Mill has long been a landmark in Granby Hollow along Aldrich Street. It first operated as a distillery and then, from 1836 to 1870, operated as woolen factory, supplying blankets during the Civil War. It became a gristmill in 1870 and was converted to a blacksmith shop in 1913. The first three photographs on these two pages show workmen during a construction phase of the Aldrich Dam and the bridge over Batchelor Brook. The fourth shows the mill below the dam.

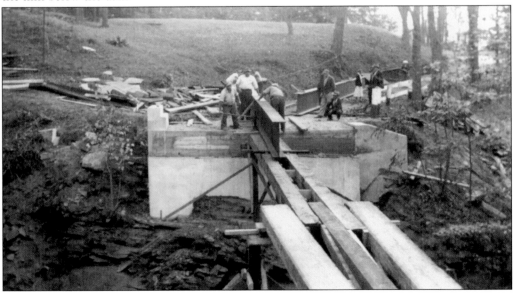

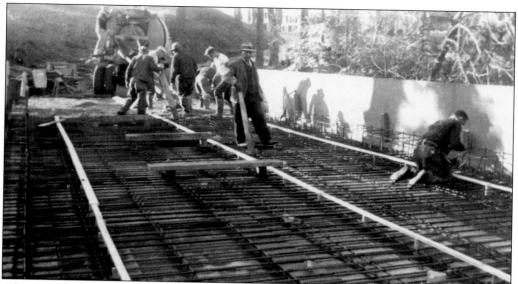

After construction of the dam, Batchelor Brook was backed up, creating Aldrich Lake, which still exists today. Inside the dam was a turbine that provided power for the mill and later provided electric power for the town and for the trolley that traversed the notch over the Mount Holyoke Range from South Hadley to Amherst. The handcrafted waterwheel shown in the photograph below never produced power but was a cosmetic construction by Elbert C. Aldrich to commemorate the 100th anniversary of his grandfather's settlement in Granby.

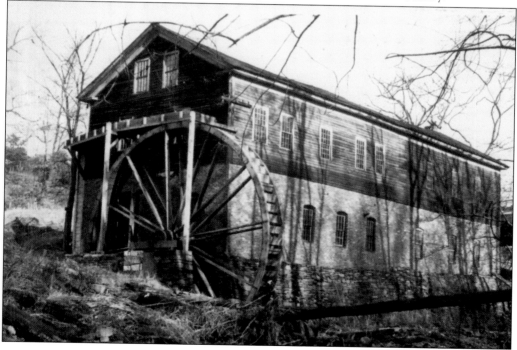

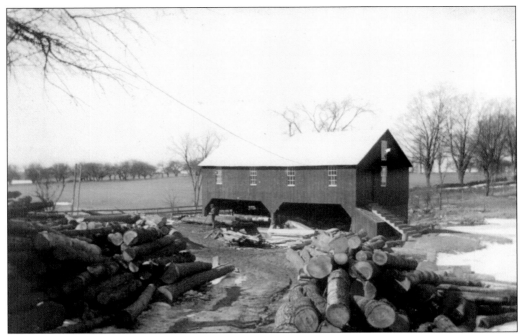

Any source of water served to power mills. The top image is of an unidentified sawmill that operated next to a pond, possibly Forge Pond, which can be seen to the right of the mill. The lumbermill below was located at the Warner home. Powered milling apparatus can be seen on the right, with men busy working in the background.

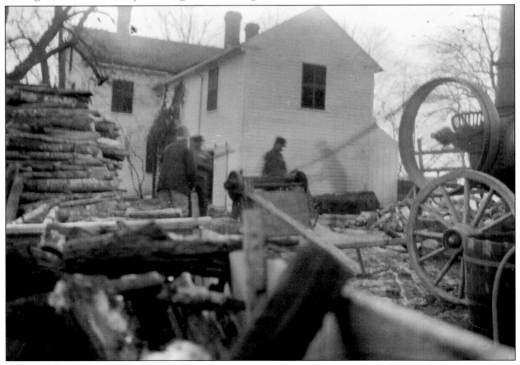

This photograph of an unidentified mill in Granby, taken by 19th-century photographer Alva Howes, shows many transient workers and their families, all of whom probably worked in the mill, including the children. In 1900, 18 percent of children from the ages of 10 to 15 were employed in jobs such as those provided by this mill in Granby.

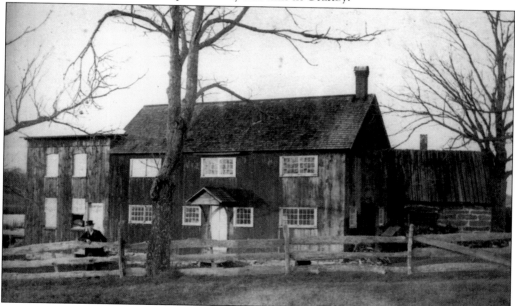

This photograph shows the Carver Mill, located on Carver Street. The ell on the right was built c. 1825 and was a blacksmith shop. The remainder of the building was added c. 1870. This mill produced reed ribs for weaving cloth, pickets for fences, and other woodwork. It also functioned as a sawmill and a grain mill.

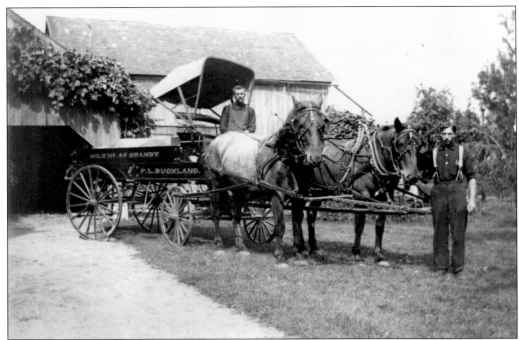

Home delivery was more important in early Granby than it is today. Farmers' families delivered vegetables and milk to town and received goods from the local stores in return. Above is the F.L. Buckland Milk Delivery wagon. The image below shows the John Bates Milk Delivery wagon. The man is probably Lester Bates, who was married to Alice Bray and lived on East Street. Lester worked several jobs, including delivery of milk. (Courtesy Evelyn Hatch.)

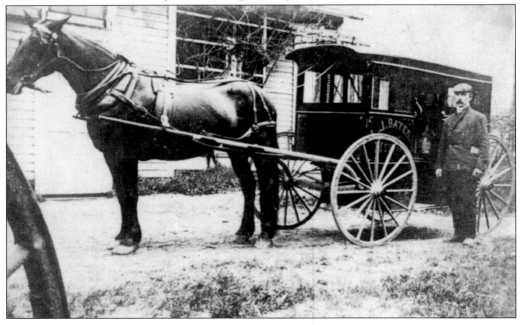

Two grocers who delivered from town to outlying farms were Charles Spooner, above, and an unidentified delivery person, below.

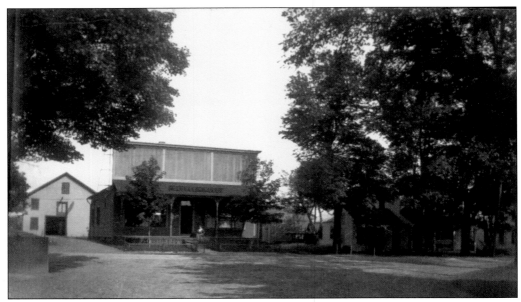

The first trading shop in Granby was operated by William Eastman at 128 Pleasant Street. He was licensed from 1758 to 1760 but was still in business in 1761, selling tea, coffee, and dishes. In 1821, Capt. Luther Henry started the first store in Granby center at 242 State Street, the present location of the Center Pharmacy. For many years, the Granby post office occupied part of the store, and at one time, the telephone switchboard was located there. The photograph above shows the George F. Bell store. The photograph below shows the George Bell home, next to the store, and Bell's delivery wagon.

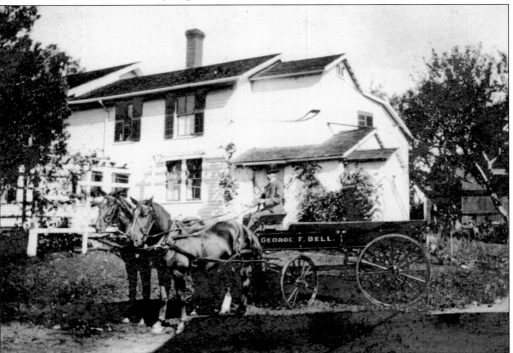

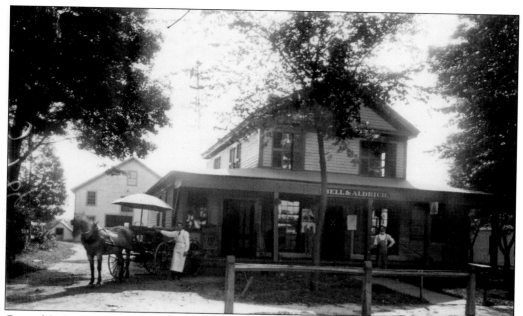

Oramel L. Davis ran the store at 242 State Street for about 15 years. These photographs show two views of the store. The image above, taken by 19th-century photographer Alva Howes, shows the delivery wagon in front of the store. The photograph below shows the store with the Bell home to the left.

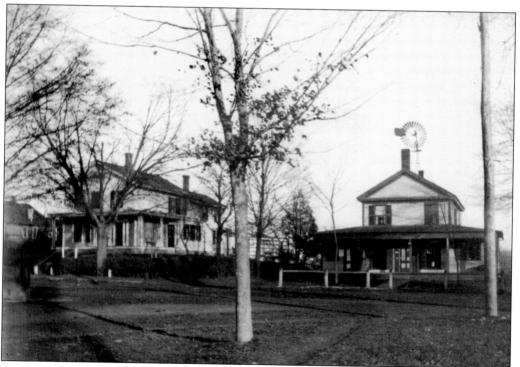

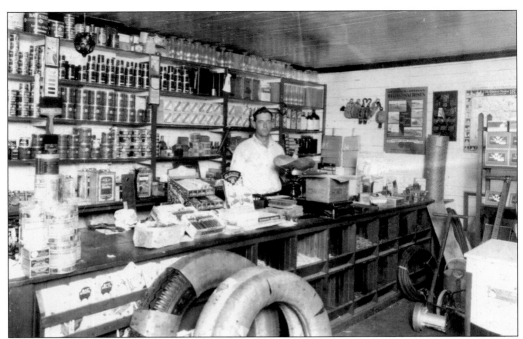

This photograph shows the interior of the center store when Herbert R. Durant owned it in the 1920s. Pause here to look around the store to see what he was selling at that time.

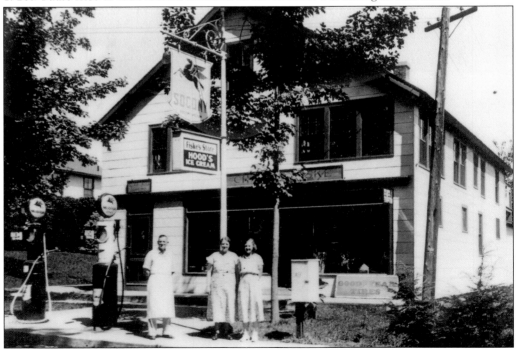

This is a view of 242 State Street in 1938, when the center store was operated by Charles Fiske. He and his family pose in front of the store, just below the signs for Socony gasoline and Hood's ice cream.

The Granby Cooperative Creamery Association received its charter in January 1889. At the start of their operations at 40 Center Street, in the building shown here, only 15 farmers supplied cream, but the number grew to 58 farmers by 1895. As time passed, Granby farmers became dissatisfied with the price they received for cream, and the creamery eventually ceased operation.

The first blacksmith shop in Granby center operated from the southeast end of the common. Hiram Harris started the shop c. 1836. However, neighbors disliked the unsightly shed that housed the shop, so they reportedly ran a stick through the chimney and twisted it until the chimney collapsed. Undeterred, Harris rebuilt the chimney, but the shop was eventually moved to this location at 246 State Street, where it was photographed by Alva Howes c. 1900.

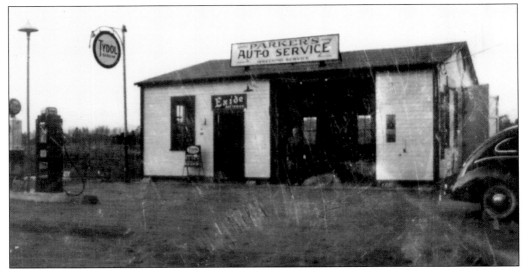

As the importance of gasoline and the use of automobiles for transportation grew, service stations appeared in Granby along U.S. Route 202. This photograph shows Parker's Auto Service, run by Lindolph Parker on West State Street in the 1950s. Parker can be seen just inside the garage entrance. (Courtesy Linda Parker Smith.)

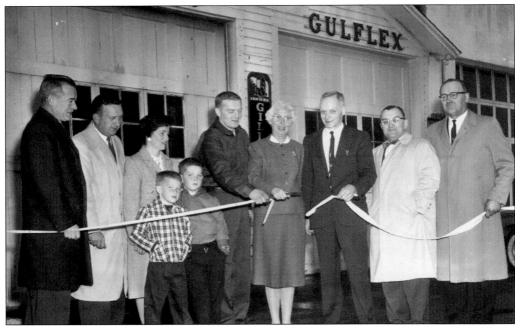

Also along U.S. Route 202 is Dressel's Service Station. Robert Dressel entered the business with a small station in 1931. This photograph was taken when Martin A. Merrill bought the business in 1962. Pictured are, from left to right, Raymond W. Randall and Romeo N. Monat, selectmen; Jean and Martin Merrill; Dorothy and Robert Dressel; Frank Laflamme, president of the Granby Chamber of Commerce; and Roy A. Nutting, board of selectmen chairman. The children in front are Scott Merrill, age six, and Russell Merrill, age eight. (Courtesy Martin Merrill.)

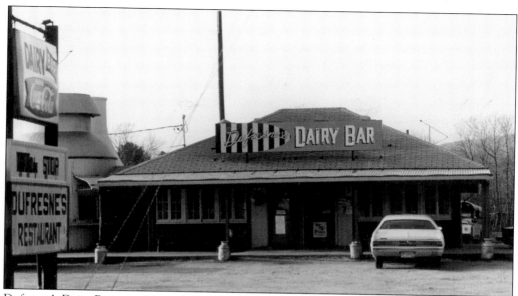

Dufresne's Dairy Bar, now Manny's Restaurant, stands along U.S. Route 202 across the highway from the Dufresne farm, part of which is now Dufresne Park, a town-owned recreation area. Frederick and Yvette Normand Dufresne operated the Dufresne farm and the dairy bar from 1963 to 1977. The dairy bar was run as a tearoom before World War II. The milk can to the left of the dairy bar building was manufactured in Chicopee and moved to Granby during the Great Depression. In the photograph below, Carlton Nash is showing his vintage automobile to Frederick Dufresne in front of the dairy bar. (Courtesy Denise Dufresne.)

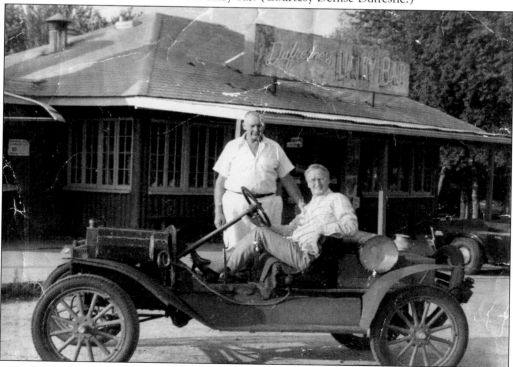

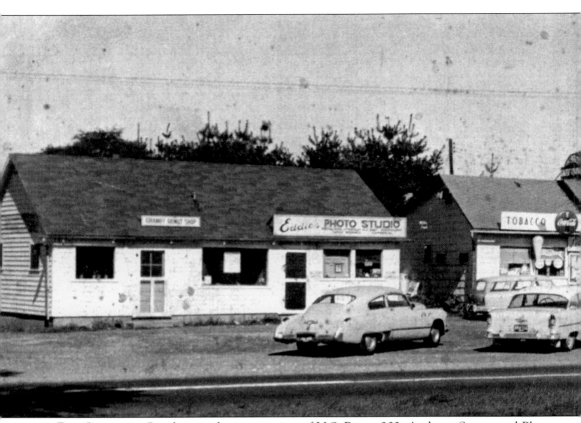

Five Corners in Granby—at the intersection of U.S. Route 202, Amherst Street, and Pleasant Street—has always been a business center. This photograph, taken in the 1950s, shows the Granby Donut Shop, Eddie's Photo Studio, Cora Willett's "the Spot" restaurant, the Farmers Exchange grocery store, and Roger "Tony" Fornier's barbershop. According to Martin Merrill,

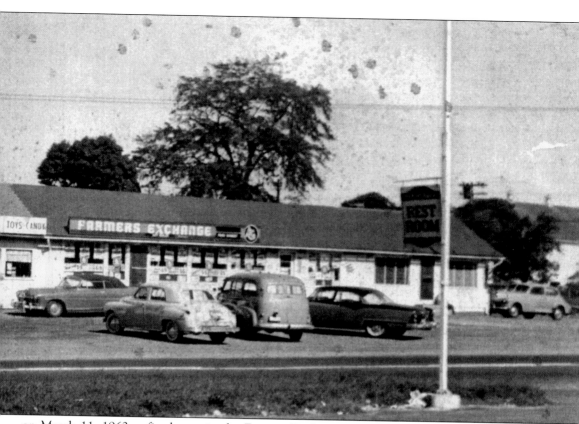

on March 11, 1962, a fire began in the Farmers Exchange. The damage was left unrepaired, and the business area deteriorated until the buildings were razed a few years ago. The new post office now occupies the site.

The Cloutier home, once the Fuller home and the Moody home, on the southeast side of Five Corners, was used as a tavern in Colonial times. During the 1860s, it was a stop on the Underground Railroad. In the mid-1940s, Bill Cloutier moved the house to a location farther up Pleasant Street to make room for a gas station. In the photograph above, the Cloutier home is at the right. The carriage house, later used as a gift shop, is to the left of the home, and the building on the far left, formerly the barn, is the home of Pleasant Street Auto. In the photograph below, the house is jacked up, ready to move. (Courtesy Camille Cloutier.)

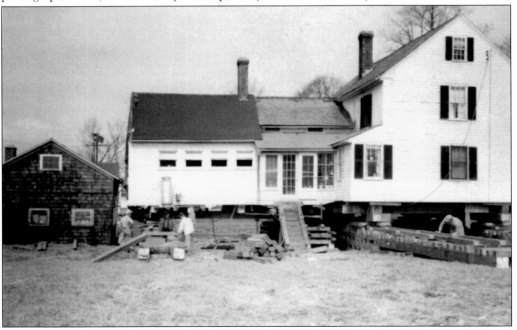

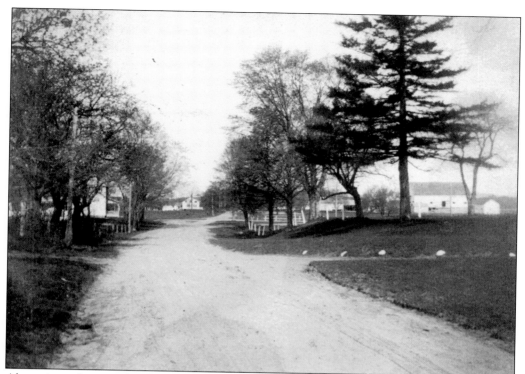

Above is a photograph of Five Corners, looking east on Pleasant Street in 1910. Below is a photograph looking in the same direction, showing the Texaco service station built by Bill Cloutier in the 1940s. The gift shop can be seen at the left, behind the Texaco station. (Courtesy Camille Cloutier.)

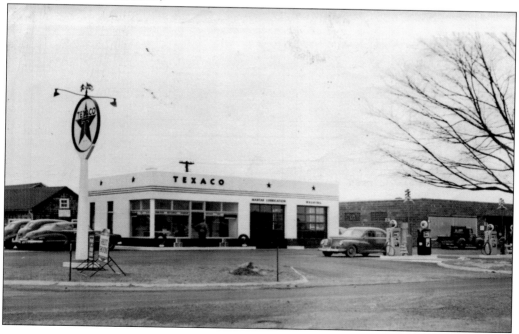

This carriage house was originally part of the Cloutier house complex. It was converted to a gift shop in the mid-1940s. (Courtesy Camille Cloutier.)

After it was burned, the Cloutier barn was rebuilt and converted to a machine shop, the Granby Machine Company, which did subcontract work during World War I for the Van Norman Company of Springfield. The building still stands at 72 Pleasant Street and now houses Pleasant Street Auto Body and Repair. (Courtesy Camille Cloutier.)

In 1903, 40 Granby residents organized the Granby Telephone and Telegraph Company in order to rectify the problems they were having with telephone service. A switchboard was installed in George Bell's store in Granby center. In 1928, Mr. and Mrs. Glenn Snow purchased all the stock. They eventually sold the company to Alston Mugnier, Robert Bacon, Vernon Luce, and Elliott Gould. The company was eventually moved to 215 State Street, where it is today, marked by this unobtrusive sign, along U.S. Route 202. The photograph below shows Alston Mugnier hard at work in the 1960s. (Courtesy Granby Telephone.)

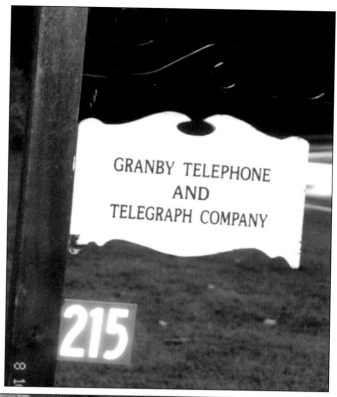

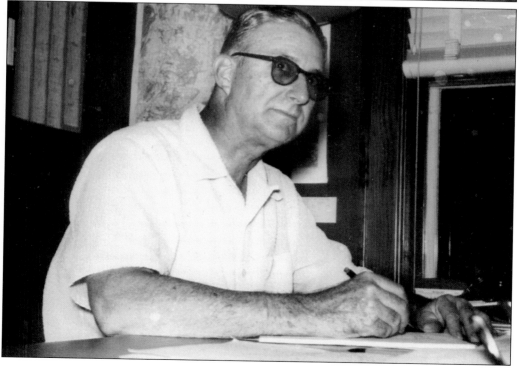

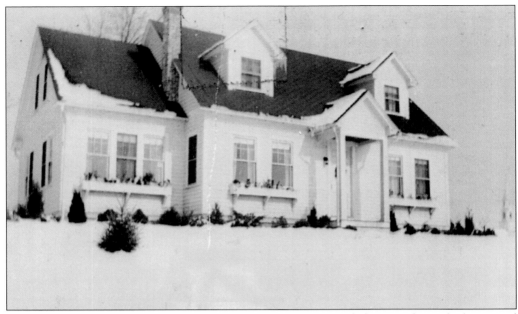

The photograph above shows the 215 State Street home of the Granby Telephone and Telegraph Company in the 1930s. The image below shows the original parking garage, situated behind the offices, in 1951. (Courtesy Granby Telephone.)

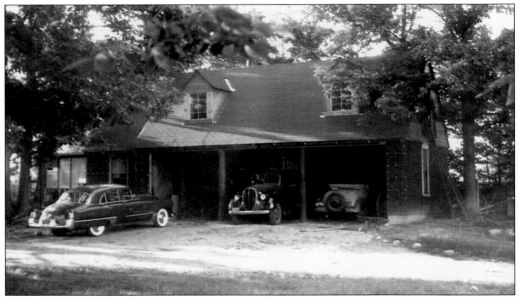

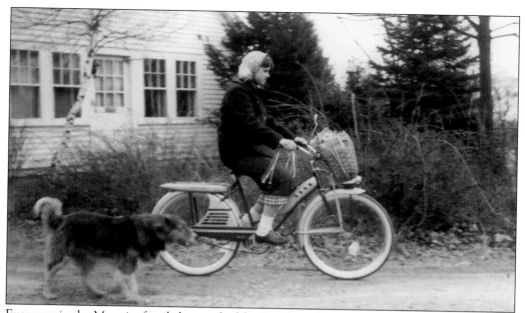

Everyone in the Mugnier family has worked for Granby Telephone at one time or another. This photograph shows Mary Jo Mugnier using her bicycle to deliver telephone books and telegrams in 1956. (Courtesy Granby Telephone.)

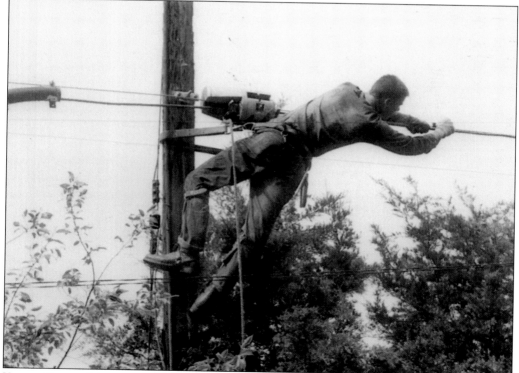

Young George Mugnier works hard to keep telephone lines working properly in this 1956 photograph. (Courtesy Granby Telephone.)

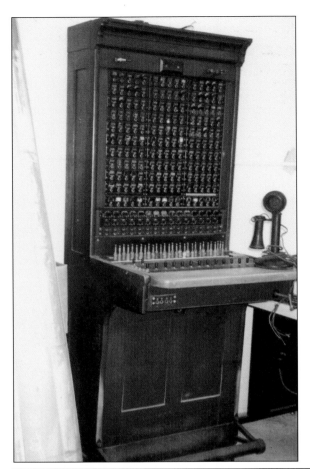

Here are two views of the switchboard for the Granby Telephone and Telegraph Company. The photograph to the left shows the original switchboard, once installed in the George Bell store in Granby Center. The photograph below shows a slightly more advanced version, installed in the building at 215 State Street. (Courtesy Granby Telephone.)

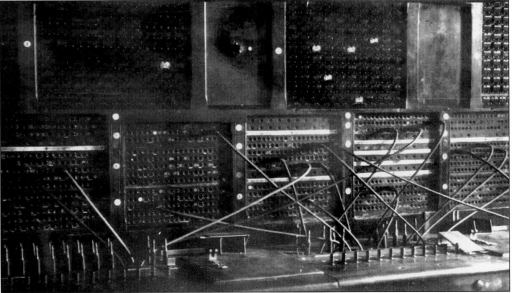

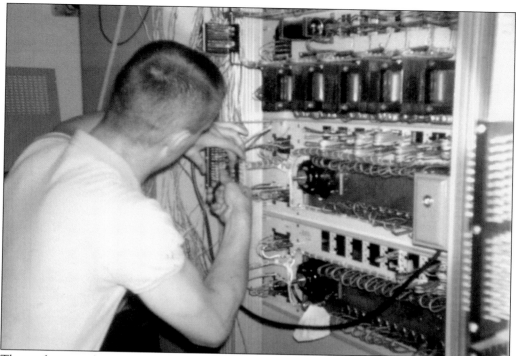

These photographs show the progress Granby Telephone and Telegraph has made through the 20th century. Above, repairs are made to the fiberoptic switchboard. The image below shows a selection of telephones, past and present, used by customers in Granby. (Courtesy Granby Telephone.)

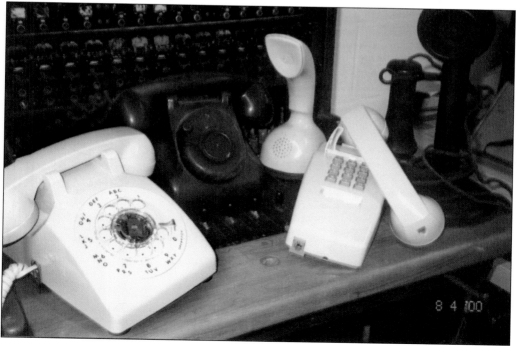

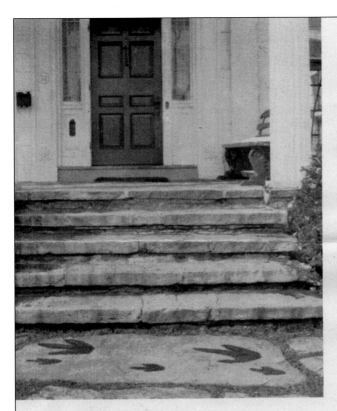

A famed scientist arranged these attractive doorsteps. The home belonged to Edward Hitchcock of Amherst College, the "Father of Paleontology." It is now owned by Professor Orton L. Clark of the Science Department of Massachusetts State College.

■

The late famed General George S. Patton, Jr., was a proud owner and admirer of dinosaur tracks. His daughter wrote us, "Daddy and Mother had always longed to have a set of tracks . . . My Father was very much interested in them and was terribly pleased when he was home last summer to see them in the library."

The world's oldest authenticated symbols of life on this earth were made by dinosaurs well over a million years ago. So completely rare were they until recently when an apparent breeding ground or drinking place for these pre-historic monsters was discovered, that people traveled thousands of miles to see treasured museum specimens of their footprints.

In 1933, Carlton Nash, a young geologist, discovered a stony ledge in South Hadley, Massachusetts, which contained "some imprints" left by the ponderous dinosaurs that dominated life on this planet during this early pre-historic era. Seven years later, after completing further studies in geology at Amherst College, he purchased the small area containing his secret find.

Discovery of this ledge established further imperishable proof that dinosaurs once roamed this valley, and of Nature's great geological "embalming" process. The mud, in which these pre-historic creatures once walked, first became petrified because of its clayish-iron and cement-like mixture, and later was compressed by the great glacier which covered the earth during the Ice Age. Then came volcanic actions and consequent earth's warpage which brought the prints back to the surface where they were finally exposed by erosion — thereby completing the cycle. Now we have prized possessions, preserved in stone, to be passed along to future generations.

In the 1930s, Carlton Nash, a Granby native and geology student, bought property on the Granby-South Hadley line. There, he would eventually uncover more than 3,000 tracks that dinosaurs left in this area more than 100 million years ago. Visitors flocked to his quarry, reputed to be the largest repository of dinosaur tracks in the world. Thus Nash Dinoland was born. It still exists today, run by Carlton Nash's son Kornel. (Courtesy Kornel Nash.)

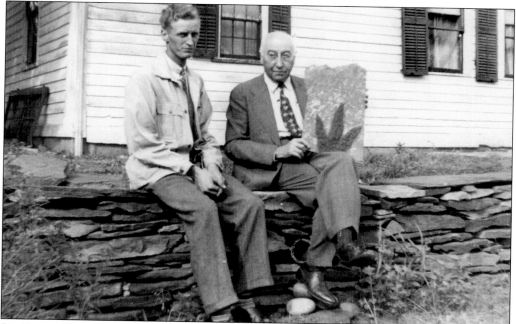

Dr. Barnum Brown (right), paleontologist from the American Museum of Natural History in New York, visits Carlton Nash at Dinoland in 1941. (Courtesy of Kornel Nash.)

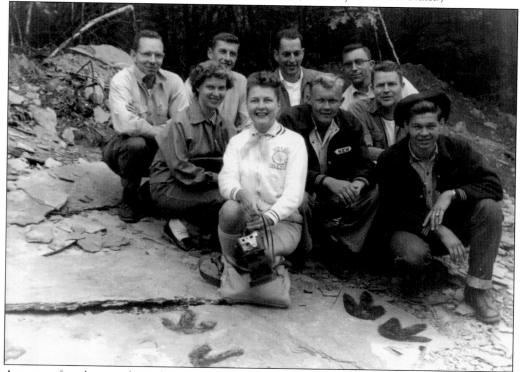

A group of geology students from Upsala College in New Jersey visited Dinoland in the 1960s. Many tracks from Dinoland are displayed in the Boston Museum of Natural History.

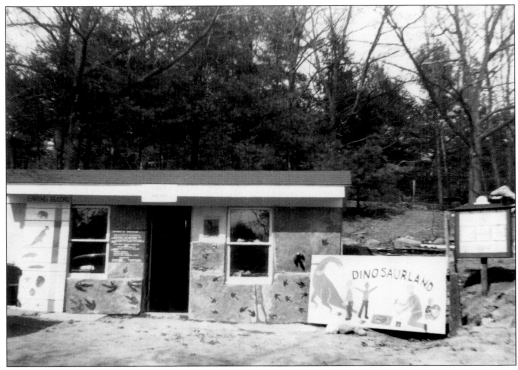

Due to overwhelming response to his discovery, Carlton built a small display room on Aldrich Street in 1950, where he and his family operated a store and showroom until 1960.

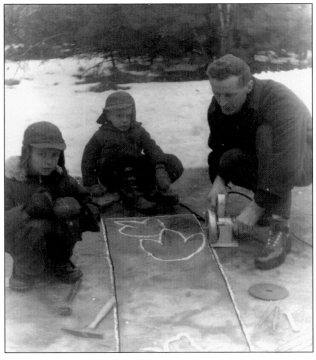

Charles Nash (left), Carlton T. Nash (center), and Carlton S. Nash quarry dinosaur tracks in the 1950s.

Carlton Nash displays a new find, some of the largest tracks in the quarry, in the 1950s.

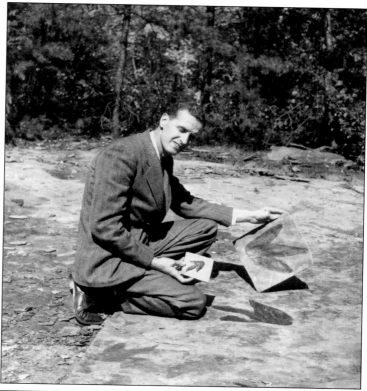

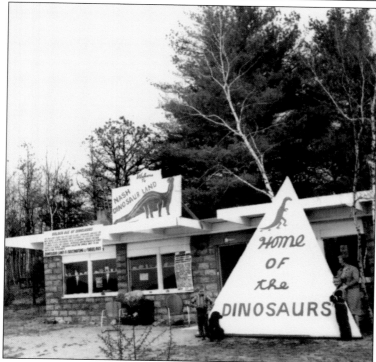

Eventually, a new store and showroom had to be constructed to accommodate the classes of elementary, secondary, and college students, as well as the many tour buses that stopped at Nash Dinoland. This new building was built farther back on the property off Aldrich Street in the 1960s.

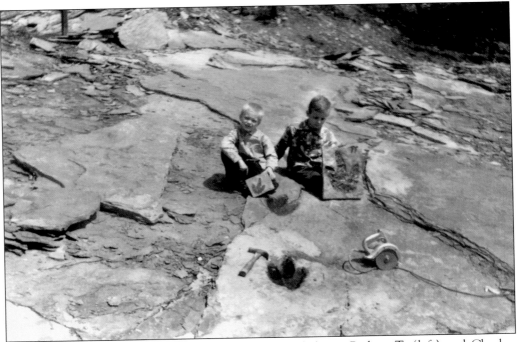

Young and old alike enjoy the quarry. Here the Nash boys, Carlton T. (left) and Charles, investigate some of the larger tracks, perhaps wondering if the creatures might pop out of the forest at any moment.

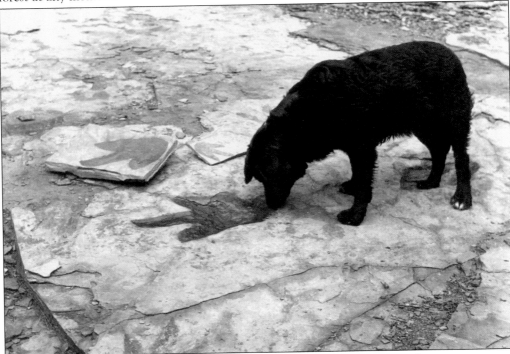

The Nash family dog is hot on the trail of a dinosaur, 100 million years too late.

Five

SCHOOLS

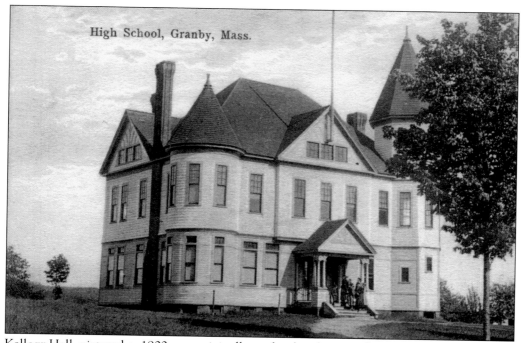

High School, Granby, Mass.

Kellogg Hall, pictured c. 1900, was originally a school and is now the town hall.

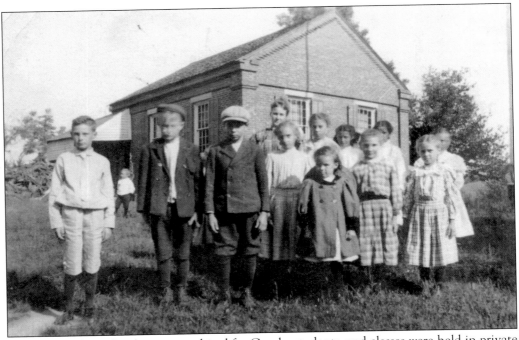

In 1768, the first schoolmaster was hired for Granby students, and classes were held in private homes until 1813, when the first buildings were built, one for each newly formed district. The school pictured here was located in the center of town. It still stands at 227 State Street. Emma Barney's class is shown.

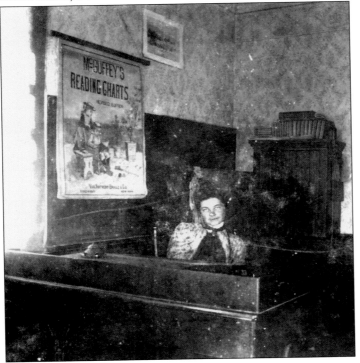

The South Street district school was located on the right side of South Street on the approach to the back gate of Westover Air Reserve Base. Pictured in its interior is Myra F. Chapin Scott, teacher. Note the reading chart on the wall above her.

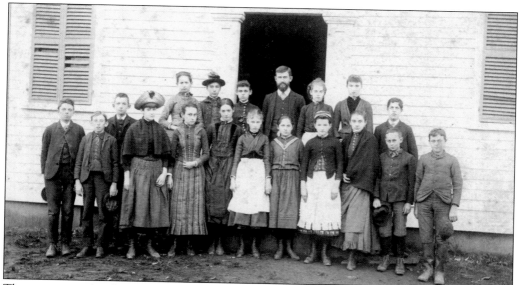

The grammar school was located in the center. Known also as the Town House, the building is now property of the Granby Historical Association. The Town House had no running water. Toilets were out back, which deterred students from leaving class to use it, especially in winter. In the morning, the custodian brought pails of water from Kellogg Hall and filled a drinking crock in the classroom.

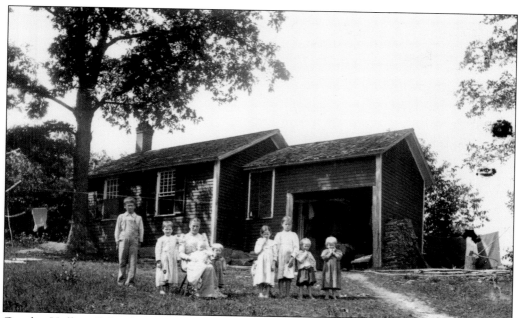

Granby Hollow School was located at the corner of Amherst Street and Aldrich Street. Elbert Aldrich attended this school as a child and remembered how an older boy was paid to arrive at school early to start the fire. This photograph was taken by 19th-century photographer Alva Howes after the school had been converted into a summer home.

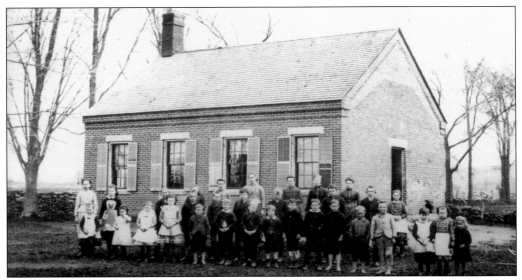

The district school at Ludlow City was located on Taylor Street, serving the neighborhood children of Ludlow and Granby. Town support rotated every four years until 1929, when the school was closed and the pupils transported to the school at the center. Pictured here in 1885 are, from left to right, the following: (front row) Jessie Tilley Bigelow, ? Deteau, Lottie Carver, Hattie Carver, ? Deteau, George Tilley, Walter Gove, Harry Crafts, George Fuller, R. Samuel White, Elmer Kendall, Adolph Dostal, Francis Dostal, Lizzie Carver Anderson, Mary Carver, and Lizzie Crafts; (middle row) Ada Taylor Olds, Eva Lyman Dickinson, Edward Crafts, George Crafts, Austin R. Carver, William Crafts, Fred Carver, Clarence Lyman, Walter Warner, and ? Deteau; (back row) Carrie Crafts, Mable Kendall, May Tilley, Goldey Ryder, ? Phelps (teacher), and Mary Crafts.

Students pose at the Carver Street School in June 1927 on the last day of class. From left to right are Norman Taylor, Muriel Jenson, Dolly White, Helen M., Elizabeth Z., Robert Taylor, Olin White, Viola Lyman, Lillian Taylor, Charles Shy, Anna Z., and Lottie M. (Courtesy Viola Lyman Hatch.)

These are the students at the Carver Street School in June 1927 on the last day of class, in a less formal pose than on the previous page. (Courtesy Viola Lyman Hatch.)

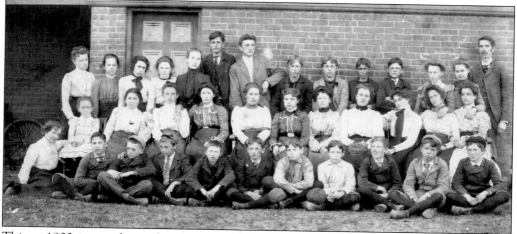

This *c.* 1900 image shows the classes taught by Mr. and Mrs. Bixby. From left to right are the following: (front row) Winifred Fiske, Dwight Moody, Frank Kindall, Henry Fuller, Roy Bartlett, Lawrence Forward, William Bell, Wilmot Fiske, and Harry Chapin; (middle row) Gladys Rust, Bertha O'Neil, Anna Rust, Sadie Tilley, Lizzie Crofts, Jessie Tilley, Bertha Walker, Anna Warner, Emily Aldrich, Irene Easton, and Vera Bartlett; (back row) Mrs. Bixby, Ellen DeWitt, Ethel Buckwell, Gertrude Newell, Katharine Bell, Paul Bidwell, Winifred Forward, George Nutting, Watson Porter, Clifford Cooke, Rutherford Ferry, Jennie Graves, Ruth Taylor, and Mr. Bixby.

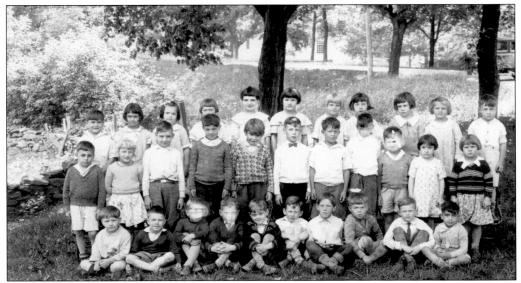

Miss Noonan's class at Center School is shown here in 1931. From left to right are the following: (front row) Lajoie, Perrault, Cooley, Harnish, Caproska, Nutting, Dressel, French, Gaudette, Holman, and Dewitt; (middle row) Black, Wolf, Noble, unidentified, Rosenski, Paul Marcott, Dewitt, Sapowski, Cooke, Beaulfe, and Szaban; (back row) Perrault, unidentified, Dietz, Ellison, Leo ?, unidentified, Ferriter, Hare, and Shacrarian. (Courtesy Catherine Camp.)

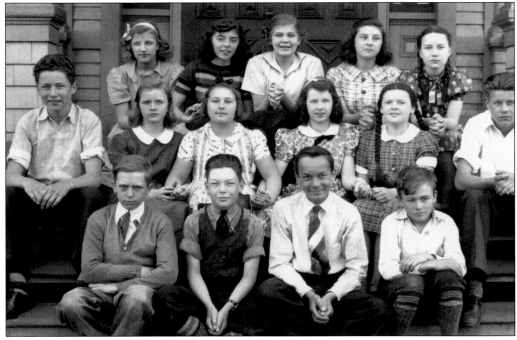

The Center School class of 1938 includes, from left to right, the following: (front row) Gertrude Wolfe, Harriet Clark, Gloria Bissel, Simone Gaudette, and Catherine French; (middle row) Dean Ellison, Claire Norris, Rose Szaban, Phyllis Breen, Joan Cooley, and Giles Dewitt; (back row) Alfred Dietz, Arthur Budd, George Giroux, and Richard Hatch.

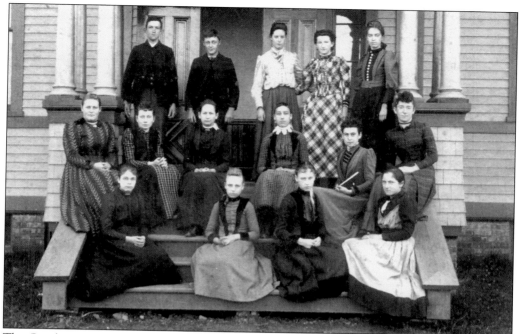

The Granby High School class of 1891 is pictured here on the steps of Kellogg Hall. From left to right are the following: (front row) Maybel Thayer, Rachel Frost, Edna Smith, and Myrtie Davis; (middle row) Dora Blish, ? Sutshen, Ada Taylor, Della Taylor, Bertha Batchelor, and Helen Tonlin; (back row) Walter Warner, Trevor Tilley, Mary Witt, Addie Barnes, and Edith Kellogg.

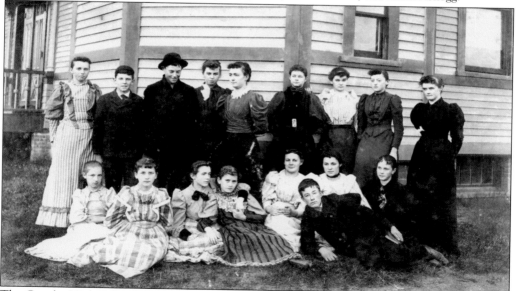

The Granby High School classes of 1896 and 1897 are pictured here outside Kellogg Hall. From left to right are the following: (front row) Sarah Frost, Frances Bell, Della Albee, Grace Taylor, Joseph Witt, Amy Blish, Rosabelle Blish, and Carrie Dickinson; (back row) Eva Lyman, Will Ferry, Herman Aldrich, Lilla Worthington, Mabel Harris, Myra Chapin, May Smith, Carrie Taylor, and teacher Mary Brigham.

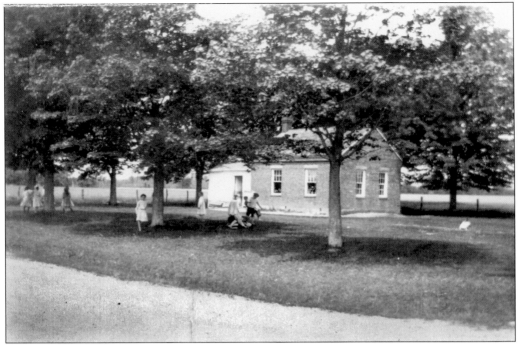

Children play under the trees at the brick schoolhouse in Ludlow City *c.* 1910.

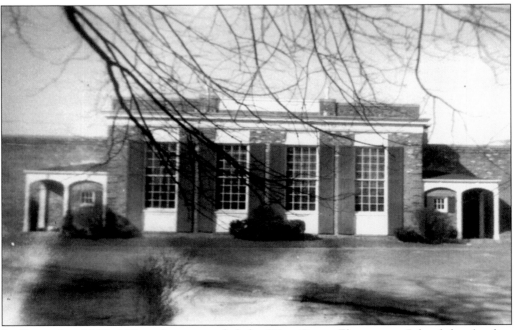

In September 1942, 160 students attended the West Street Elementary School for the first time. This photograph shows the original facade of the building, before the 1955 addition changed its appearance.

MINI

REPORT
By The Forth Grades at
WEST STREET SCHOO

KINDERGARTEN

Last month the Kindergarten classes were studying their families and families around the world. They also started their letters and numbers. They have been working with food as a part of their study of the five senses. They wore blind folds and tasted different foods. They made popcorn and pudding and also recorded their voices on tape. This month they are working on rhyming words, Christmas and emotions. The Kindergarten classes wish you a ♥ Merry Christmas".

Stephanie Laplante

FIRST GRADE

A couple of weeks ago all the first grades made pictures of their family for Open House. When their families came they had to pick out themselves.

The classes have been studying phonics such as short vowels and consonants and putting them together to make words. Also they were studying light with Mrs. Weaver in the Learning Center. They watched film strips and did experiments. When they were finished they went back to teach the other children. In math Mrs. Merrit says, " They are getting into real tough stuff, like adding three to every number up to ten ".

Everyone has been working very hard on their papers for the bulletin board too.

Mrs. Merrit's class has been making a paper chain in their spare time. They hope to get it all around the room. They are also making pictures of Santa's work shop.

All the First Grades wish everyone a very Merry Christmas.

Kristina Sillich

SECOND GRADE

Mrs. Cox's class was studying Eskimos, and made snow candy. They also made life size Eskimos and a clay Eskimo village. In the Learning Center they are doing math and science projects. Mrs. O'Neil's reading class is in a new reading book. They are also going to the Learning Center. Mrs. Rice's class has a new girl in their class. Her name is Kristine Hebert. Mrs. Dennett's class is studying storms and how they are helpful and harmful to man. They did some experiments with water. They measured things in Math. A group of children went around the school measuring whatever they could find. They will make a report on them. The second grade classes are learning about Australia. They are studying about space in their rooms and in the Learning Center. Mrs. Aiello is going to help them with a Christmas bulletin board. They all hope you have a very nice Christmas.

Linda Williams

PRINCIPAL'S CORNER

Mr. Langone said the classrooms, the halls, and Christmas tree in the courtyard look very nice.

On December 23rd all the children will be singing Christmas carols in the learning center. Have a joyous Holiday and a Happy New Year.

Suzanne Barnish

Ten fourth-graders at the West Street School produced the *Mini Report* during the 1976–1977 school year. With a circulation of 300 for the first issue, they planned to increase it to 400 for the December issue. According to Marie Quirk, the Granby reporter to the *Transcript Telegram*, local newspapers should beware of this competition. "Armed with a pad, pencil, and tape recorder, these reporters faithfully record the answers to their questions of who, what, where, when, and why." Students involved in the Language Arts Enrichment Program with teacher Dretta Weaver were Suzanne Barnish, Sharon Carver, Sherry Cote, Debra Forget, Lori Hough, James Kumiega, Stephanie Laplante, Kristina Sillich, Linda Williams, and David Stater.

By the 1970s, education had progressed well beyond the three Rs. The Granby Town Hall's first floor was renovated by carpentry students from the Granby Junior-Senior High School in April 1974. Posing proudly before a sample of the newly paneled wall are, from left to right, David Miller, Robert Carter, Francis Venne, John Lastowski, Dennis Turgeon, Ronald Erickson, and John Hauschild.

Mike Nadeau and Linda Marcy are in rehearsal for *Prisoner of Second Avenue*, the senior class entry in a one-act play contest at Granby High School during the 1960s.

Six

ORGANIZATIONS AND EVENTS

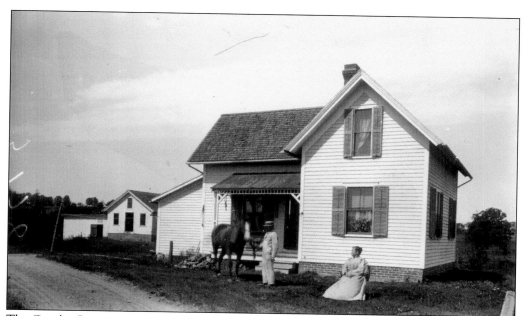

The Granby Cooperative Creamery Association, which collected cream from farmers and made butter, was started at 40 Center Street in 1888 under the direction of the Grange. It flourished in the late 1800s.

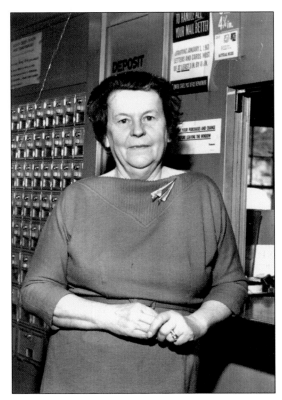

The Granby post office has been located in many places, the first being in Belcher's store in Granby center. When Rosanna Ruel, pictured here, became postmaster, the post office was moved to Kellogg Hall and then to the house at 248 State Street. Ruel was postmaster from 1943 to 1965. (Courtesy Ruth Ruel.)

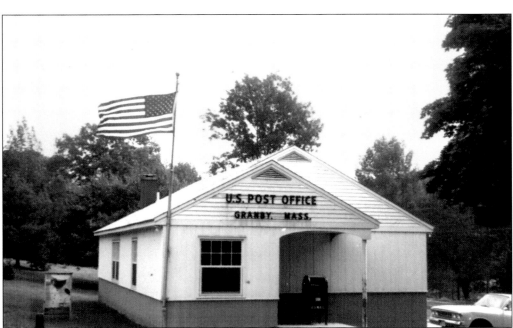

In 1955, the post office relocated to 220 West State Street. This picture shows the Granby post office in 1968 at 220 West State Street, the present site of Brooks Real Estate.

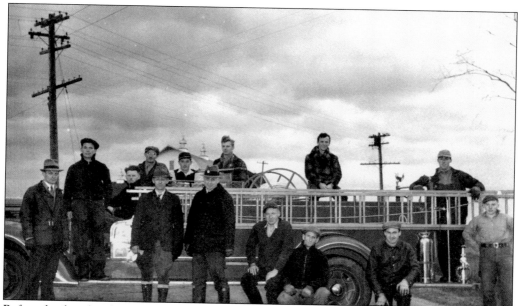

Before the first fire department was organized in 1938, the most effective firefighting technique was to empty the home or barn of its contents before the building burned to the ground. This photograph shows members of Granby's newly formed fire department. They are, from left to right, Robert Dressel (fire chief), Wallace Bray, Raymond Dickenson, William Gallup, Alden Blake, ? Loiselle, George Bell, Harry Zymbroski, ? Howe, Harold Taylor (sitting on wheel), Edmund Zymbroski (standing on truck), ? Labrie, Mark Pappel, and Robert Hatch. (Courtesy Martin Merrill.)

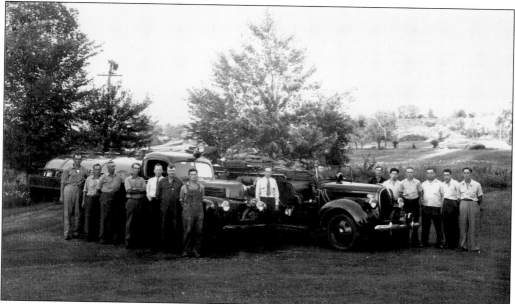

The Granby Fire Department in 1943 included Joseph Murzin, Frank Murzin, Harold Taylor, George McPherson, James Gambel, Wallace Bray, Bob Dressel, Bill Gallup, George Scott, George Randall, Jacob Merrill, Arthur Perrault, and Nelson Ingham. (Courtesy Martin Merrill.)

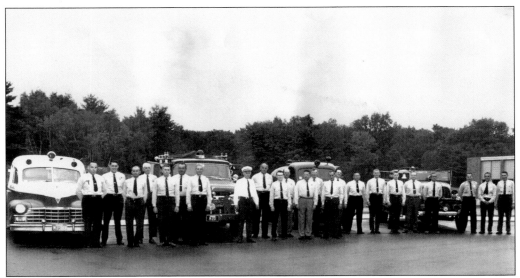

Pictured here is the Granby Fire Department in 1960 at the West Street School. They are, left to right, John Baker, Richard Perrault, Edward Harnish, Earl Ingham, Myron Ingham, Ed Martin, Arthur Hauschild, Robert Dressel (fire chief), Joseph Murzin, Allen Buss, John Rosinski, George Scott, William Gallup, Frank Murzin, Dorius Desroschers, Joseph Lajoie, Martin Merrill, Ronald Chamberlain, Roy White, George Galusha, Dwight "Bud" Tucker, John McCool, and Arthur Perrault.

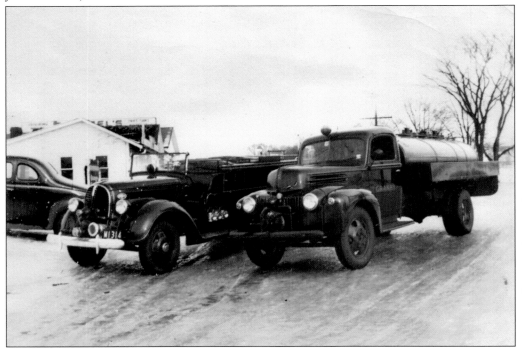

In 1942, the Granby Fire Department purchased its first tank truck, which held 1,100 gallons. This allowed the department to fight fires farther away from a water source. Pictured here are the original truck and the tank truck.

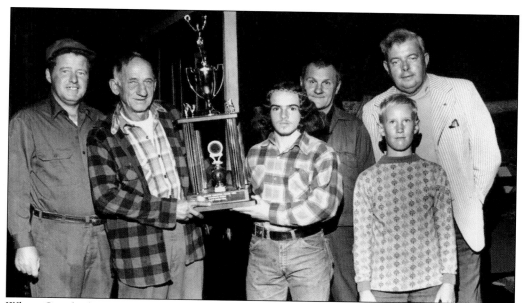

When Granby became a town, roads were merely widened trails. Today, the Granby Highway Department is more a department of public works, caring not only for roads and bridges but also for lawns, town signs, and sewers. In this photograph, members of the Granby Highway Department receive the grand prize for their float entered in Belchertown's centennial parade. Pictured are, from left to right, Bill Barry, Frank Murzin, unidentified, Mike Szaban, Jon Gillespie, and Gary Whitlock (Belchertown selectman).

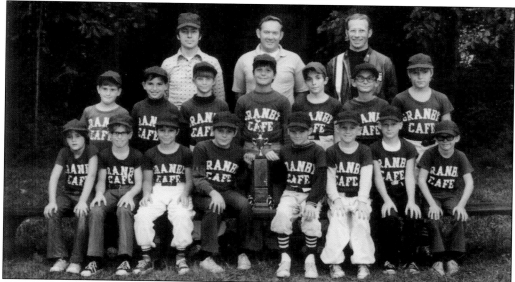

Organized sports have a long history in Granby. Here, the Granby Farm League champions pose with their trophy for the third season in a row. From left to right are the following: (front row) Mark Richard, Ken Beauleau, Dave Maheu, Skippy Robidoux, Steve Mallalieu, Derek Withrow, James Hawks, and Gary Mallalieu; (middle row) Gary Pacicot, Roger Karrasch, Ken Hoyle, John Nickless, Harry Ilse, Walter Kumiega, and Gary Laverderiere; (back row) coach Ken Hoyle, league director Ray Racicot, and manager Dick Mallalieu.

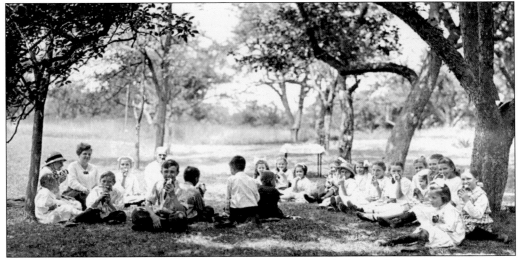

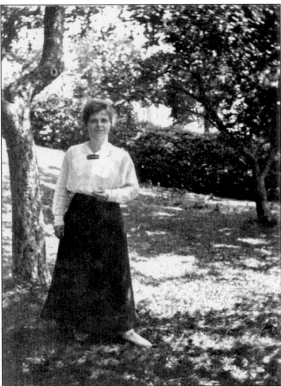

The Arthur P. Smith family lived at 4 Porter Street and maintained on their property Wander Wood, a beautiful area for public use. In a letter dated July 2, 1978, Bodine Smith Fowler wrote of the picture above, "This is a picture of the Summer Vacation School at Wander Wood in Granby. My mother hired the teacher for the summer to supervise the children in games, arm exercises to music, and various activities. The teacher's name was Miss Burr. Mrs. Kalunka is at right of Miss Burr in the picnic picture." To the left is a photograph of Burr.

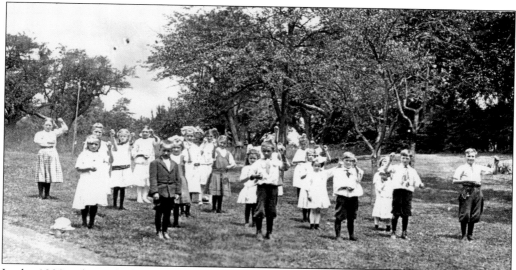

In the 1920s, physical education was very different from what it is today. Here, children do arm exercises to music during Summer Vacation Camp at Wander Wood behind 4 Porter Street.

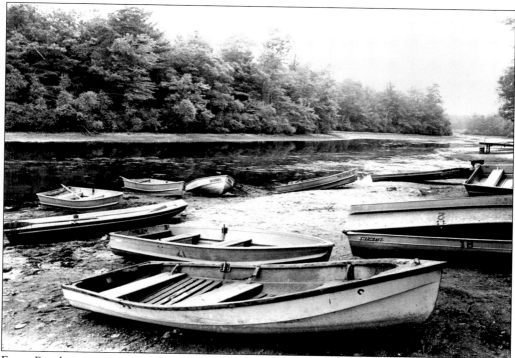

Forge Pond was a swimming and boating area for Granby residents during the summer. During the winter, it was a skating and ice-fishing site. In 1969, the Hampshire County Commissioners found the dam and spillway unsafe and ordered the pond drained until repairs could be made. Today, the Forge Pond dam remains unrepaired.

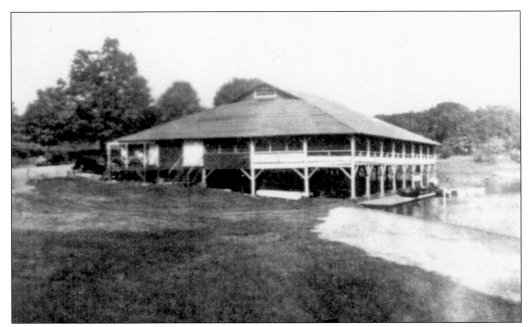

A favorite spot for recreation in the early 20th century was Aldrich Lake. Overlooking the man-made part of the lake in Granby was a pavilion that variously served as a roller rink, a dance hall, and a dining room for Boy Scouts during camping season. It was also used by the Holyoke YMCA for gymnastics during their summer day camp program in the 1960s.

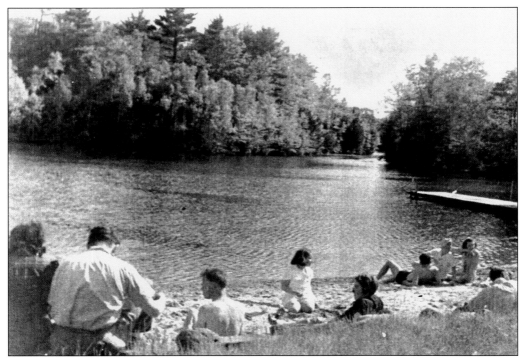

Well into the 1940s, bathers enjoyed Aldrich Lake's sandy beaches during the summer.

Scouting has deep roots in Granby. This image, one of the earliest photographs of a scout available, shows Girl Scout Captain Wilson in 1923.

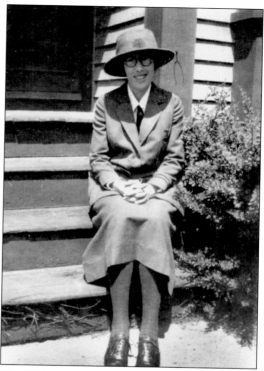

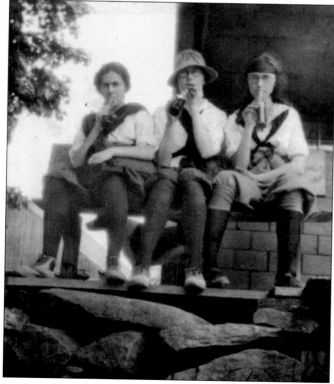

This photograph from the Kellogg family album shows a Girl Scouts hike to Mount Wachusett in 1923. Note their uniforms and the soda bottles from which they drink.

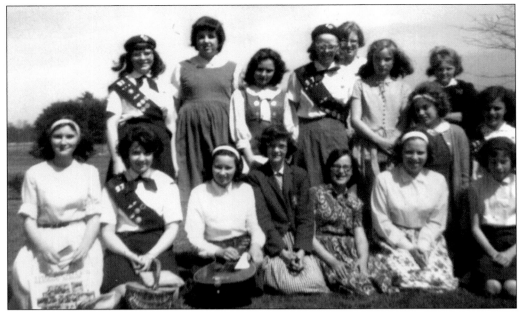

Pictured here are members of the Girl Scout Intermediate Troop from 1963 to 1964.

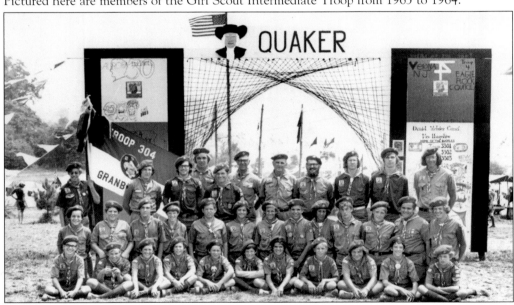

Granby Boy Scout Troop 304 attended the National Jamboree in Moraine State Park, Pennsylvania, in 1973. From left to right are the following: (first row) Paul Beaulieu, Sean Burke, Steve Denette, Matt Denette, Joe Denette, Bob Niquette, unidentified, Glen Quataker, Rocky Heroux, Bobby Niquette, and Eddie Glasson; (second row) Joe Gendreau, Mike Miller, Greg Browne, Kevin Morin, Tom Tonelli, Dennis Beauchaund, Jay Fluet, Kenny Longfield, Gene Os, Russ Ruel, George Burke, Bob Paulin, and Dave Kachinski; (third row) Richard Beaulieu, Mike Curran, Phil Dennette, Eugene Longfield, and Chris Denette; (fourth row) unidentified, leader Charles Dulong, leader Phil Burdick, leader Phil Denette, Jim French, and Larry Dulong. (Courtesy Ruth Ruel.)

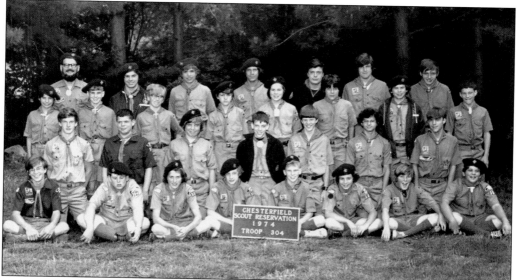

Here is Granby Boy Scout Troop 304 at Chesterfield Scout Reservation in 1974. They are, from left to right, as follows: (first row) Paul Beaulieu, Mike Miller, Steve Denette, Eddie Glasson, Glen Quataker, Joe Gondreau, Jim Curran, and unidentified; (second row) Russ Ruel, Tom Tonelli, Steve Leocopalos, Bobby Niquette, Kevin Morin, Dennis Beauchand, and Greg Brown; (third row) Phil Gendread, Michael Quataker, Ken Beaulieau, Rusty Gonyer, Joe Denette, Greg Longfield, Matt Denette, and ? Niquette; (fourth row) Phil Denette, Chris Denette, Kenny Longfield, Gene Os, Neil Pelletier, Mike Corran, and Mike Slater. (Courtesy Ruth Ruel.)

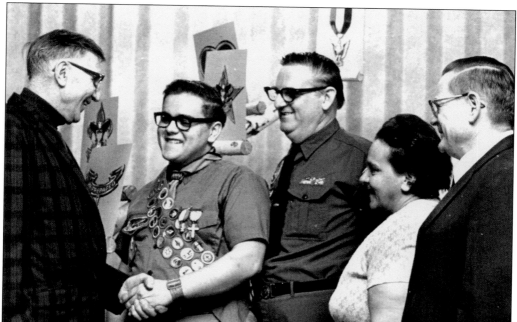

Joe Paulin attains the rank of Eagle Scout. From left to right are William Gallup (leader), Joe Paulin, Clarence Burdick, and Dorothy and Joseph Paulin.

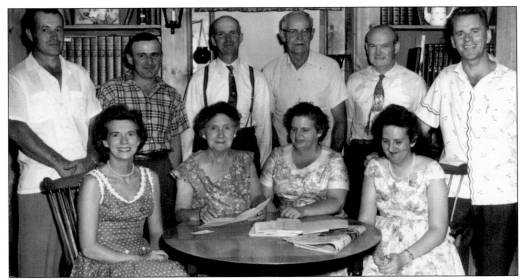

The Granby Grange was an integral part of Granby town life from 1887 until 1993. According to its literature, it "is an organization meeting in a fraternal atmosphere in which there is a high moral tone, devoid of religious bias, and a patriotic acceptance of responsibility without partisanship. It cooperates with the church, school, and all worthy agencies of the community to develop citizenship and responsibility." The Grange members pictured here are, from left to right, as follows: (front row) Barbara Erickson, Irene King, Gladys Lyman, and Claire Hatch; (back row) Francis Dewitt, Richard Hatch, Lawrence Lyman, Wilbur Easton, Andrew Vanderpoel, and John Erickson. (Courtesy Dean Hatch.)

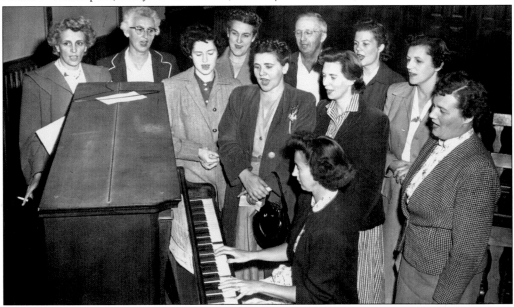

Singing at the Grange meeting on Monday, September 27, 1955, are, from left to right, Blanche Tucker, Dorothy Dressel, Beverly Galusha, Jean Gallup, Anna Clark, John Scott, Barbara Ericson, Joan Carpenter, Barbara Papel, and Betty Hauschild. Brenda Cummings is at the piano. (Courtesy Warren McKinstry.)

In April 1955, the Grange presented a spoof on Granby entitled *The Whole Town's Talking*. These cast members are, from left to right, George Galusha, Nancy Taylor White, Margaret Vanderpoel Slate, Mildred Dietz Gibbs (seated), Maureen McCool, and Robert Carpenter. (Courtesy Warren McKinstry.)

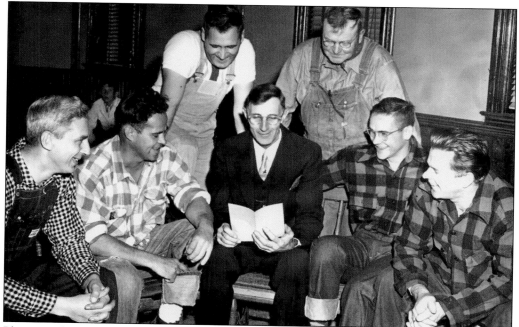

Planning the Granby Grange Minstrel and Square Dance on Monday, September 27, 1955, are, from left to right, the following: (front row) Art Hauschild, Dwight Tucker, William Gallup, George Galusha, and John Ericson; (back row) Robert Carpenter and Robert Hatch. (Courtesy Warren McKinstry.)

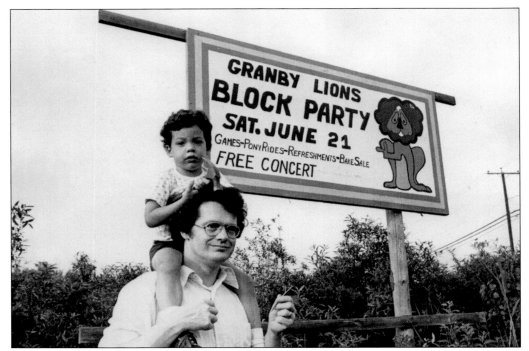

The motto of the Granby Lions Club is "We Serve," and they certainly have since they were chartered in October 1953. Pictured here beneath the Lions Club block party advertisement are Robert Wood and his son.

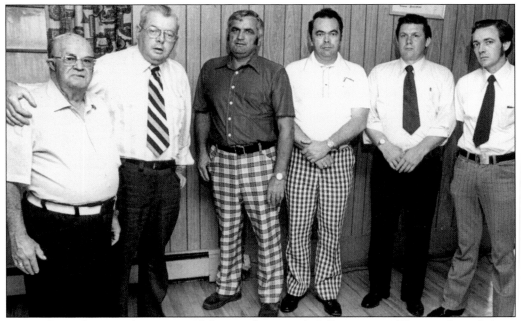

Pictured at the Granby Lions Club Installation of Officers in 1975 are, from left to right, Jack Gillespie, secretary; Warren Cooke, treasurer; Joe Currier, first vice president; Wayne Avery, third vice president; and Richard Fox, lion tamer.

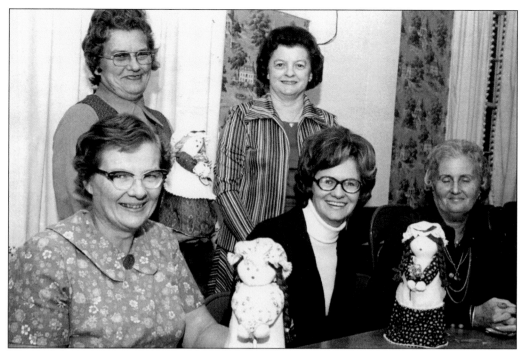

The Granby Woman's Club was begun by Ada Warner Gray in April 1908, and it continues to play a vital part in community relations in Granby. Shown here planning a fundraiser are, from left to right, the following: (front row) Phebe Nash, Brenda Knight, and Peggy Bray; (back row) Dorothy Lempke and Maudetta Taylor.

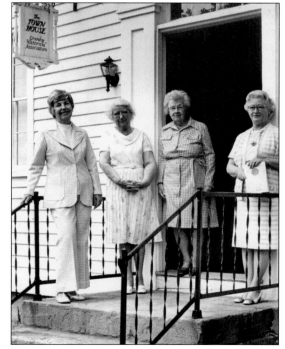

The Granby Historical Association was formed in 1946 when a group of citizens concerned with preserving Granby's history met in Kellogg Hall. Here, past officers of the historical association pose on the steps of the Town House. They are, from left to right, historian Virginia Aldrich, Margaret Dickinson, Gertrude Taylor, and Isabel Mondor.

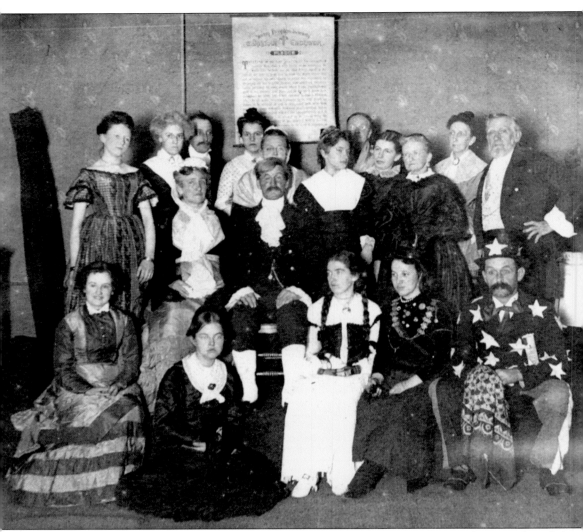

These Christian Endeavor youths are dressed for a patriotic celebration. They are, from left to right, as follows: (front row) Ida Harding, Edith Chapin, Edith Kellogg, Rose Blish, and George Blish (Rose's father); (middle row) Bertha Walker (in wedding dress), Eliza Harris, Sam Dickinson, Myrtie Bell, and Ellen Walker; (back row) Lucy Prentiss, Harold Bryant, Anna Randall, Carrie Forward, Maud Clark, and Carrie Rust.

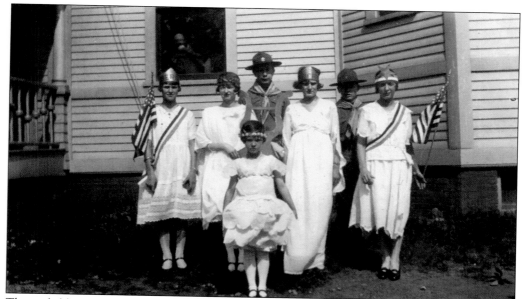

These children are dressed for the Memorial Day celebration of 1926. Note the Boy Scouts in the back row and the girls' patriotic costumes.

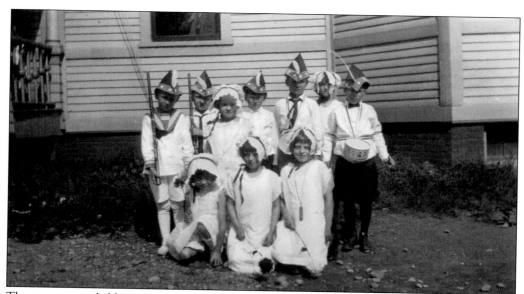

These younger children are dressed up as early Granby settlers on Memorial Day 1926. Note the boys' Yankee Doodle hats, complete with feathers.

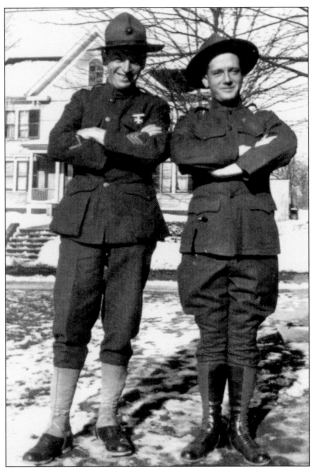

Of the few military photographs in the Granby Historical Association archives, one colorful soldier stands out. Herbert Durant is shown on the right, outside his home, now Aldrich Hall, with a friend (possibly Ruddie Ferry). Herbert Durant served during World War I in Fort Sill, Oklahoma, in Battery C, 14th Field Artillery, waiting to go to war in 1917. He immortalized his frustration in the following poem:

We've dug enough dummy trenches,
And fired at enough Huns made of wood;
We've fought enough umpired battles,
And fired more shell than we should,
We've had our turn at trench digging
And drilled knee deep in mud,
We've roughed it, hiked it, cursed it, and liked it,
Though we've never been out for blood.

For nearly two years we've stomached the training,
To teach the School of Fire the game
Drilling, Parading, Firing, and Craving
Yet they say we're only soldiering by name,
We know the soldiers manual backwards,

We're tired of this old, old stuff,
For we were ready to fight with all our might,
To call the Kaiser's bluff.

We never got marching orders
To sail for England or France;
We've been here for nearly two years,
Hopelessly awaiting our chance.
Not one in this Fourteenth Regiment
But what responded with a will
We've seen regiment after regiment come and
 leave Fort Sill.
Still here we are, earnestly awaiting some day to
 show our skill.

Another World War I soldier, Eastman Smith, poses outside his home at 4 Porter Street, having just returned from France. (Courtesy Bodine Smith Fowler.)

Booker, Mary Jo, and Paul Mugnier pose together in uniform in 1956.

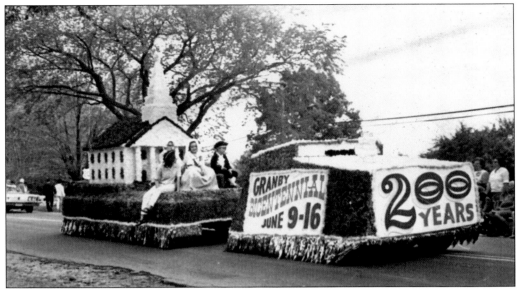

June 11, 1968, marked Granby's bicentennial. During those 200 years, Granby grew from an unobtrusive farming town to a vibrant community, ready to face the 21st century. The following images come from Granby's bicentennial celebration. This was the grand-prize-winning float from the Church of Christ. On this float, the zeros in the number 200 are shaped as eyes looking to the future.

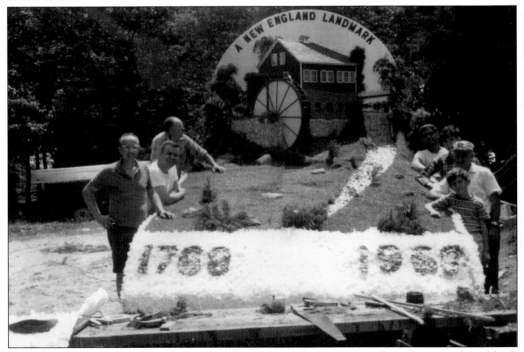

Immaculate Heart of Mary Catholic Church presented this impressive float, showing the Aldrich Mill and Water Wheel. Around the float are, from left to right, Richard Beaulieu, unidentified, Earnest Perrault, Alexander Desilets, David Desilets, Alfonse LaBrie, and Donald LaBrie.

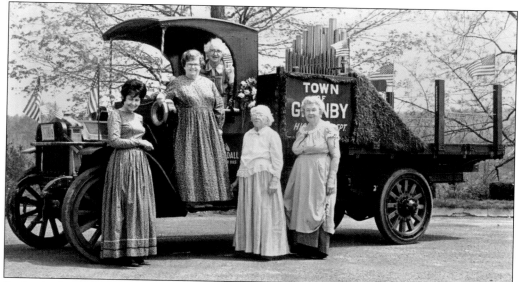

Posing in front of Frank Falk's Federal Truck and Calliope are, from left to right, Anne Meister, Gladys Lyman, Dorothy Dressel, Bertha O'Neill, and Gertrude Taylor.

"Sweet History" was the title of this bicentennial cake by Henry Randall, a winner in the baking contest. Pictured behind the cake are Henry Randall (left), Mrs. Lionel Morissette (center), and Betty White.

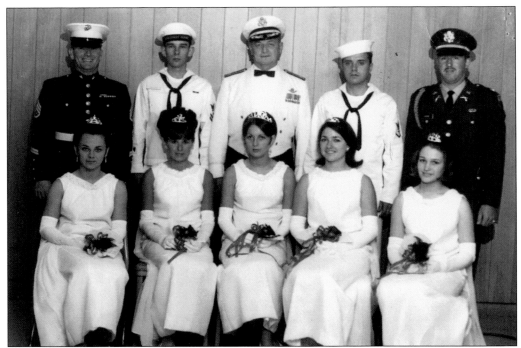

The bicentennial queen and her court pose with representatives of all armed services from Westover Air Force Base. The queen and her court are, from left to right, Patricia Marcotte, Jane Schultz, Lorraine Carriveau, Susan Trompke (queen), Nancy Zucker, and Jane Mondor. Representing the armed services are, from left to right, S.Sgt Clayton Crewse, PO2 George W. Keegan, Lt. Col. Clifford H. Dwinell, HM3 Kevin McCool, and Capt. Stephen Estee.

TOWN OF GRANBY
MASSACHUSETTS. 01033

1768 — *Bicentennial* — 1968

July 1, 1968

Department of the Air Force
Headquarters Eighth Air Force (SAC)
Commander Westover Air Force Base
Westover Air Force Base, Mass. 01022

Dear Sir:

We, the Committee wish to express our appreciation for authorizing Lt. Col. Clifford Dwinell to represent the U. S. Air Force at Granby's Bicentennial Birthday Celebration.

The evening through his participation in the program will long be remembered as one of the outstanding highlights of the entire celebration.

We are enclosing a picture taken of the group together with the Queen and her Court. Thought you might enjoy having one for your files.

Sincerely,

Granby Bicentennial Birthday Committee

Lt. Col. Clifford Dwinell began his flying career in the early 1930s, worked for Piper Aviation at its inception, became a military pilot, and flew the Sacred Cow for Pres. Harry S. Truman. Dwinell and his family remained in Granby after his retirement and became vital members of the community. This letter of appreciation from the Granby Bicentennial Committee was given to Dwinell for promoting intra-community relations between Westover Air Force Base and the town of Granby.

This poster announces the annual celebration of Charter Day, promoted by the Lions Club of Granby. Charter Day commemorates the incorporation of Granby as a town on June 11, 1768.

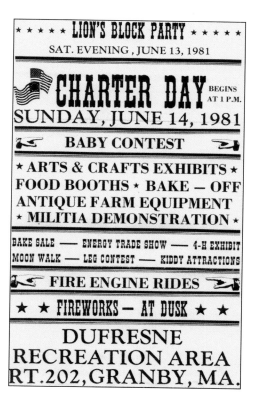

★ ★ ★ ★ LION'S BLOCK PARTY ★ ★ ★ ★
SAT. EVENING , JUNE 13, 1981

CHARTER DAY
BEGINS AT 1 P.M.

SUNDAY, JUNE 14, 1981

BABY CONTEST

★ ARTS & CRAFTS EXHIBITS ★
FOOD BOOTHS ★ BAKE — OFF
ANTIQUE FARM EQUIPMENT
★ MILITIA DEMONSTRATION ★

BAKE SALE —— ENERGY TRADE SHOW —— 4-H EXHIBIT
MOON WALK —— LEG CONTEST —— KIDDY ATTRACTIONS

FIRE ENGINE RIDES

★ ★ FIREWORKS — AT DUSK ★ ★

DUFRESNE RECREATION AREA RT.202, GRANBY, MA.

Granby's oldest female citizen, Mary Buckhout McVay, received the Aldrich Cane on November 15, 2001, from the Granby Woman's Club. In a spirit of equity, Elbert Aldrich gave a replica of the Boston Post Cane to the Woman's Club, to be given to the oldest female citizen. McVay has been a vital part of the Granby community since 1964, when she and her husband, H. Vilroy McVay, moved here from South Hadley. McVay was 92 in 2002 and resides in her home on Ferry Hill Road. (Courtesy Mary Kuntz.)

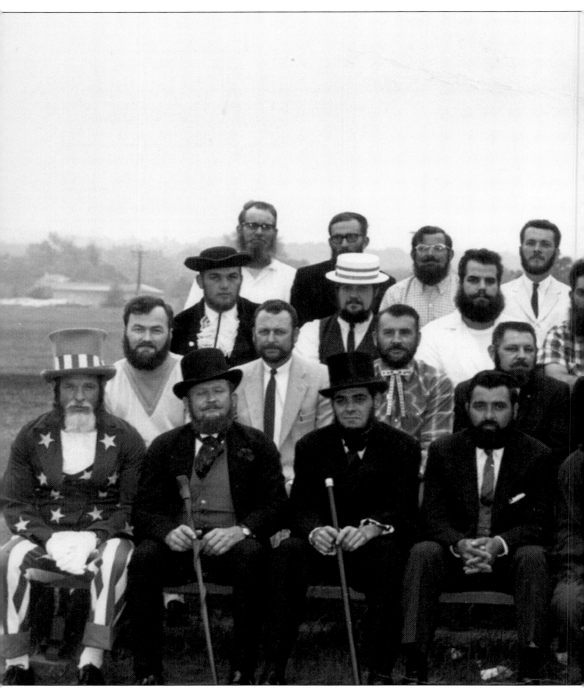

This photograph of the beards grown by men of the town for Granby's bicentennial in 1968 was taken by Raymond A. Poulin. Roger "Tony the Barber" Fournier shaved every one of them after the celebration. According to Tony, the men are, from left to right, as follows: (first row) Albert Lariviere, Lincoln White, Ted Beauchemin, Roy Masse, Bill Tucker, Tony Fournier, Wilfred Roberts, Albert Bail, and Tex Land; (second row) Roger Labonte, Art Lempke,

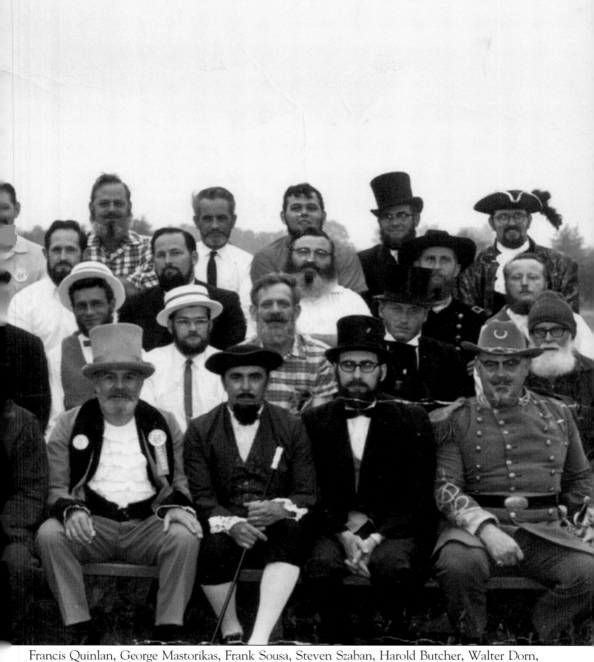

Francis Quinlan, George Mastorikas, Frank Sousa, Steven Szaban, Harold Butcher, Walter Dorn, Edward Goulet, and Wilbur Easton; (third row) Jim Wadsworth, Gerald Landry, Jim Belrose, Robert Jarrell, Malcolm Eaton, Robert Bray, M. Marion, Nelson Ingham, and Roger Ponton; (fourth row) Colin Stevenson, Art Desrosiers, Bill Duxbury, Frank Marion, George Stanley, Rene Bronner, Tom Cook, Charles Kleeberg, George Galusha, and Robert Couture. (Courtesy Roger Fournier.)

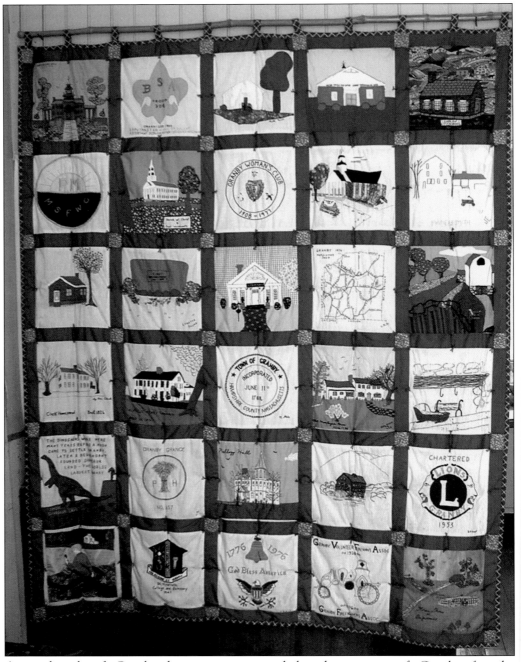

A patchwork of Granby history was created by the women of Granby for the bicentennial in 1968.